ENGLISH WATERCOLORS

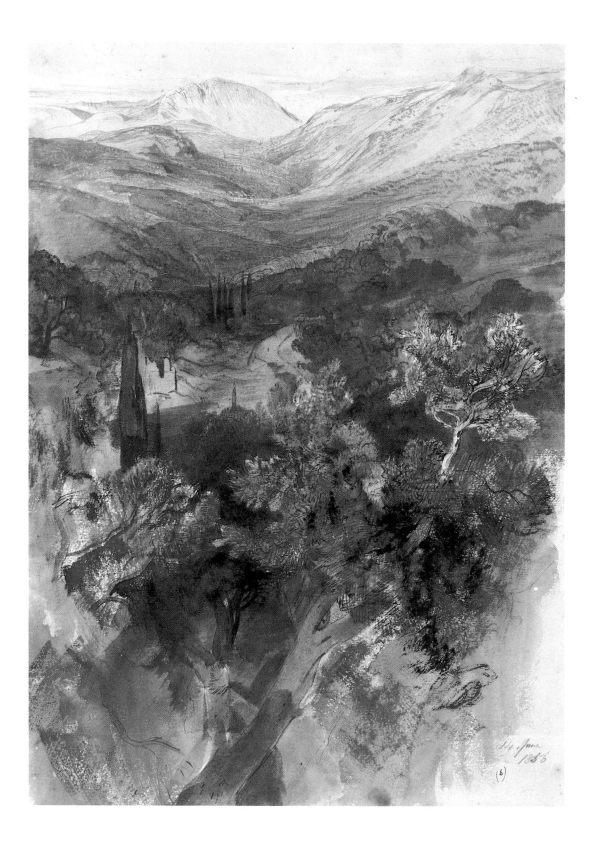

14 June
1856

(6)

ENGLISH WATERCOLORS

An Introduction

Graham Reynolds

NEW AMSTERDAM

NEW YORK

Copyright © Graham Reynolds 1950, 1988

First edition 1950
This revised edition first published in the United States of America, 1988, by
New Amsterdam Books of New York, Inc.
by arrangement with
The Herbert Press Ltd, London

New Amsterdam Books
171 Madison Avenue
New York, NY 10016

Designed by Pauline Harrison
Printed and bound in Hong Kong by South China Printing Co.

ISBN 0-941533-43-3

Frontispiece: EDWARD LEAR *Choropiskeros, Corfu* (Fig.112)

CONTENTS

FOREWORD

This survey of the English watercolour originated in the Ferens Fine Art Lectures of the University of Hull, which I gave in Scarborough in 1949. They were first published in 1950, much in the form in which they were delivered.

In revising the text for republication I have taken advantage of the growth in knowledge and interest in the subject which has been so marked in the last three decades. In particular I have profited from the greater understanding which has been reached on the place of the Victorians in the development of the art. The choice of illustrations has been varied and substantially increased, with a large proportion in colour. With these changes the present revised version aims to give an up-to-date account of its subject, whilst keeping to its original purpose of providing an introduction to this most national branch of art.

GRAHAM REYNOLDS

1 The origins of English watercolour painting *Paul Sandby, J.R. Cozens, and the eighteenth-century watercolour painters*

THE sphere of watercolour drawing, or painting, as it is variously called, is one to which English artists have made a unique contribution. In no other European country has this attractive medium been used so consistently, or for works of such high significance, as in England between the middle of the eighteenth century and the present day. Yet, in art especially, nothing is made of nothing, and the achievements of the English school rest firmly upon, and spring out of, the general development of European art. They are related to that history in two ways: both because the medium, watercolour, is a unique one, imposing special problems and with distinctive qualities and excellences of its own; and also because the English school of watercolourists has been predominantly concerned with depicting landscape; and of course landscape art was in 1750 no new discovery. Some comment about the early use of the medium of watercolour, and also about the state of landscape painting in the year 1750, which is approximately the date when our national school of watercolourists began, is therefore a desirable prelude to its history.

The characteristic which differentiates watercolour is, of course, that it is not bound together with oil. Therefore, when used purely and alone, it is transparent: the paper or other medium on which it is spread when diluted with water glows through it. Sometimes, however, it is used in conjunction with, or exclusively as, 'body colour' or 'gouache': that is, opaque white is mixed with it, and the colour is not transparent.

Watercolours in one form or another have been used from the earliest times in European art, whether alone or with body colour, for book illumination or portrait miniatures. Fresco and tempera paintings are more akin to watercolour than oil painting in their technical qualities. Watercolour drawings on paper were produced by, amongst others, Dürer and Van Dyck; and many seventeenth-century Dutch artists such as Breughel, Savery, van Avercamp and Ostade used this medium. It was not therefore a completely new and revolutionary process that our artists were developing in the middle of the eighteenth century. At the same time as this development in England the Dutch school of naturalistic landscape in watercolour was still flourishing, and a similar topographical school was arising in Switzerland to record the sublimities and beauties of Alpine scenery.

Two widely divergent types of landscape painting were current in the mid eighteenth century; the Italian type of ideal landscape and the type of naturalistic landscape which is characteristically Dutch. It was the ideal landscape which had the highest prestige in England. The names of Nicolas Poussin, Gaspard Poussin, Salvator Rosa and Claude Lorrain were held in almost equal reverence among collectors and connoisseurs; the works of these artists were engraved; their pictures, and

prints after them, were avidly bought. So effectively was the market combed for the paintings of Claude, that to the present day this master can only be studied properly in English collections. The admiration became in fact a cult; gardens were laid out on Claudean principles (Fig.51), and romantic novels interspersed with scenes inspired by Salvator Rosa. Travellers to romantic scenes were instructed to see in them the raw materials for landscape compositions. Nature must be corrected to conform with these principles. But although some aspect of the Italian seventeenth-century vision of Nature dominated English taste in the eighteenth century, these four representative artists are to some extent complementary and even antithetical.

Claude was the most beloved. In his paintings the light of sunrise or of sunset plays idyllically over a wide plain, tingeing with its glow the top of a tall tree and the figures and flocks in the foreground. The landscape is generally a wide one, given the form of an amphitheatre, and closed in by a distant range of hills which are not near enough to appear rugged or disturbing. The feeling of antiquity is brought near by a classical building which frames in one side. As in a stage-set there is on one side a foreground tree, on the other a ruin: and so on till the distant range of mountains is reached. All is peaceful, and charged with serene poetic feeling. The individual elements of the composition are taken from the country round Rome, but they have been rearranged and are not topographically·exact. Both the feeling of Claude and the feeling of Englishmen toward his pictures are marvellously summed up by Keats when he wrote, on seeing Claude's *Enchanted Castle*, of

> magic casements, opening on the foam
> Of perilous seas, in faery lands forlorn

Salvator Rosa was the complete foil to Claude. He portrays the clefts and crags of the mountains at close hand, peopled by bandits. Storms, trees riven by lightning, and Nature in her wildest and most turbulent moods are his subjects. He appealed to the awakening interest in ruggedness and what is now called romantic scenery; and in consequence, eighteenth-century travellers to the Lakes or to Italy record in their diaries and letters, with wearisome reiteration, that they have 'witnessed scenes to which only the pencil of Salvator Rosa could do justice'.

The landscapes of Nicolas Poussin and his nephew Gaspard Dughet, called Poussin, fall between these two extremes of mood. Those of Nicolas Poussin were designedly classical: he favours the full light of day, arranges his landscape generally as a fitting background to his figures, parallel to the frame of the picture, and selects a noble tree, a fine cloud form; nothing in them is mean or merely accidental, and the backgrounds are designed to provide a fitting setting to the classical or biblical legend he is illustrating. Gaspard, on the other hand, is more purely a landscape painter and approaches more nearly to the 'romantic' sentiment of Salvator Rosa, without reaching his full extremes of ruggedness.

All these artists tend to formalize or heighten the natural features of the Italian scene; hence the terms 'ideal landscape' and 'landscape compositions' which are frequently applied to their works and are often their only names. The Dutch, and the artists of northern countries generally, on the other hand, sought to transcribe Nature without idealizing her; their pictures are, or were thought in the eighteenth century to be, literally faithful to the scenes they depict. For that reason they were held in less high honour by the critics of the time; the *virtuosi* do not dilate on Ruisdael or Hobbema as they do on Claude or Salvator

Rosa. But at least one section of English artists took their inspiration from the Dutch School; and against Wilson's devotion to the Italians may be set Gainsborough's early love for the Dutch.

There are two other important influences which enter into the formation of the English school of watercolour. The first of these is the landscape, or perhaps it should rather be called the townscape, of Canaletto. Canaletto, the foremost Venetian landscape painter of his day, was actually in England from 1746 until 1754 or 1755, and the paintings and even more the drawings he made here had a far-reaching effect. He, as no one else, could enliven the topographical scene with the play of light over the buildings and the well-placed, colourful groups of elegantly dressed figures. His drawings have an unusual animation of outline, and though they were not tinted but carried out in pen and wash, their effect can clearly be traced throughout the early history of English watercolour. The other element to be remembered is the existence of a tradition of topographical draughtsmanship, founded by Wenceslaus Hollar, a native of Prague, who was brought to England by the Earl of Arundel in the mid years of the seventeenth century. His style is virtually that used by Dürer at the end of the fifteenth century. He handed on his manner of precise outline and timid tinting to Englishmen such as Francis Barlow and Francis Place, and their successors were supplying material for the engravers when a new impetus arose and transformed the native landscape art.

It is not possible to account fully for the remarkable floraison of English watercolour painting from 1750 onwards if the enormous pressure of informed taste in eighteenth-century England is under-estimated. Artists were obliged to make some attempt to fashion drawings which were

acceptable in their clients' eyes. Those who had not travelled would be familiar with the work of the great landscape painters through engravings; for the English engravers of the mid century, Vivares, Woollett and Byrne, engraved their most popular plates after these masters. But a number of the founders of the school had made the journey to Italy, either in search of self-improvement or as travelling draughtsmen in the entourage of a lord or gentleman undertaking the Grand Tour. On their journeys they saw the magnificent spectacle of the Alps and the subtle atmospheres of the Roman Campagna; and in Rome they saw original paintings by the rulers of taste. There too they met the flourishing and active colony of German and Swiss artists who were bringing a new, cosmopolitan accent into landscape composition and actually experimenting in the bolder use of watercolour and body colour.

The Dutch influence which is to be traced unmistakably beside the Italian influence, infiltrated in a somewhat different way. Gainsborough imbibed it, without ever leaving his country, through the loving study of Dutch paintings. But, for the main cause, it must not be forgotten that the geographical proximity of Holland to England, and the artistic vacuum which existed in this country in the seventeenth and eighteenth centuries, had drawn many Dutch and Flemish artists here. They were not always of the first calibre, but they faithfully reflected the prevailing mode of topographical drawings of a somewhat dry and archaic style. It was such men who satisfied the demand for views of gentlemen's seats and prospects of towns which were, apart from portraits of men and dogs, the only artistic commodity required of them in this country.

There can perhaps be no entirely adequate explanation of why, after its sporadic use in England in the sixteenth and seventeenth

centuries, watercolour became, in the mid eighteenth century, the vehicle of an independent national genre, with a continuity all its own. One of the more entertaining attempts to account for this phenomenon relates it to the order which Catherine the Great of Russia placed with Wedgwood in 1770 for a vast dinner service. This was destined for her palace 'La Grenouillerie', and was known as the 'Green Frog' service from the device placed upon all its elements. It was her intention 'to improve the taste and polish the manners of her subjects without corrupting their hearts'. She decided that the most direct path to this elevating goal was to have each of the 1282 pieces which made up the set adorned with a different view of the British countryside. Wedgwood did his best to fulfil this order by copying existing engravings of ruins, gentlemen's seats and wild scenery, but could not find enough to provide so many subjects. Accordingly he employed draughtsmen to record scenes of which he could find no prototype. The historian of the 'Old' Watercolour Society, J.L. Roget, believed that the demand created by this undertaking had led to the flowering of the national watercolour school. Unfortunately for the credit of the theory, there was a strong contingent of watercolourists established before 1770, when the order was placed; and the supplementary draughtsmen employed by Wedgwood were not conspicuous for their talent.

Already in the 1730s that indefatigable chronicler of British art, George Vertue, had admired the landscape drawings of William Taverner (Fig. 1). He was Procurator-General of the Arches Court at Canterbury, but an avid and renowned amateur artist, and an early exponent of landscape in watercolour and body colour. However his influence was limited by his diffidence. Farington was told of his idiosyncrasies by Samuel Scott, who himself made effective use of the medium in the 1740s: 'Taverner had much quaking abt. shewing his pictures, which raised their reputation . . . It was very difficult to obtain a sight of his pictures. He promised Scott to shew them to Sir Edward Walpole, who went with Scott, but were of some pretext refused admittance. Scott resented this affront & their acquaintance ceased.'

A more public and convincing start to the tradition can be found in the activities of the brothers Thomas and Paul Sandby. The elder brother, Thomas Sandby, began his professional career as Military Draughtsman in the Ordnance Office. Since the academic theory of the time relegated landscape to a lowly place in the hierarchy of types of art, far inferior to historical and mythological painting and only less disreputable than genre painting, the patronage of the armed forces was of vital importance in encouraging and sustaining the teaching and practice of landscape in the mid eighteenth century. It was the need to study and record the terrain, the lie of the land, which led to the establishment of the post of Drawing Master at the Royal Military Academy, Woolwich, to which Paul Sandby succeeded in 1768. Similar needs led to the invitations which Captain Cook issued to various artists, including John Webber (Fig.8), to accompany him on his voyages to record the discoveries.

Thomas Sandby made an early start on his duties as Military Draughtsman by recording aspects of the Duke of Cumberland's Culloden campaign of 1745 and 1746 in Scotland, making a fluent use of watercolour in his drawings. But from mid career he mainly restricted the application of his talents to architectural design and landscape gardening. He was appointed the first Professor of Architecture on the foundation of the Royal Academy in 1768. Many of his later watercolours depict the newer buildings of London seen with

the eye of a practising architect; these drawings were often embellished with lively groups of figures added by his brother Paul Sandby, as is the case with *The Piazza, Covent Garden* (Fig.2).

Paul Sandby, who was eight years younger, had been taught by his brother Thomas. He made a far more extensive and varied use of water-colour and body colour throughout the century and from that circumstance deserves, if any single individual does, the title 'Father of the English watercolour'.

Paul Sandby was an incorrigible and fervent experimenter; he was the first Englishman to use the newly found technique of aquatint; he was constantly trying new ways of making colours, and his earlier ambition lay in oil painting. It was his urge for experiment which led him to pay equal attention to painting in gouache and in pure watercolour. In style he was an eclectic. He never travelled outside England, Scotland and Wales, but of course he was fully aware of the fashionable enthusiasms and closely in touch with

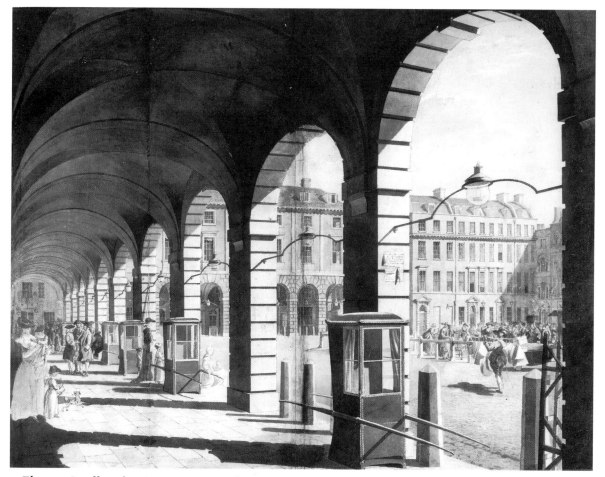

2 **Thomas Sandby** *The Piazza, Covent Garden*

the world of prints. At times he made formal Italian compositions in the manner of Claude or Poussin; but for preference he confined himself to the more literal transcription of scenes in the places he knew and travelled to. He had no taste for the excessively rugged, the mountain cliffs of Rosa, but the perspective schemes of Canaletto often sway him, and he is not averse to combining with them effects of sunrise or sunset. Taken all in all, he recalls Dutch as much as Italian models; he is a sort of disciple of Claude working in the vernacular. But this very eclecticism resulted in his forming a highly individual style; he escapes classification with other schools and becomes wholly English. He shows his natural temper in his choice of scenes, in which antiquities are combined with gentle rusticity; and he is as interested in the figures in the foreground as the landscape itself, delighting in the gestures of his maidservant and the attitudes of the gardeners working beside his Bayswater studio (Fig.3) no less than in the groups of builders, soldiers and laundresses outside the local inn, The Old Swan (Fig.4).

Again, in point of style, Sandby's watercolours and gouaches are drawn, not painted, that is to say we are conscious in them of the linear effect, the gay, swirling, elegant rhythm of the outline. Sandby has brought his calligraphy into harmony with colour just as he has brought his various models in draughtsmanship into a harmonious conception of composition.

In his landscape Sandby sets out to give a matter-of-fact rendering of what is actually before his eyes. Towering and gnarled trees and effects of atmosphere enter into his compositions (Fig.5), and he is always delighted with the figures in significant action that he can introduce in his pictures. These figures indeed do much to counteract the slight trace of an unnaturalized foreignness

3 Paul Sandby *The Artist's Studio, St George's Row, Bayswater*

which may be sensed in some of his pictures; for they are the brothers and sisters of the English men and women in the works of Hogarth, Hayman and the group of admirable book-illustrators working at the same time.

Paul Sandby, then, may be called the father of English watercolour painting because he was the first of our artists systematically to combine colour and drawing in any considerable body of work; and he gives evidence of his paternity not only in his work but in his contacts with the art of his time. He touched the art world at every point; he was active in the negotiations which led to the foundation of the Royal Academy; he bought paintings secretly from Richard Wilson to keep him from starving; he engraved drawings of Greece made by William Pars, a younger and rising draughtsman. Drawings of Warwick by Canaletto were in his collection, besides prints from all the Roman masters of landscape. He owned the watercolour *A Sandpit at Woolwich* by William Taverner (Fig.1), and had many pupils among the coming

generation of watercolourists, of whom the most prominent was Michael Angelo Rooker.

The period immediately following the maturity of Sandby – that is to say, the 'sixties, 'seventies and 'eighties of the eighteenth century – is, for all that it lacks the glamour of the greatest names in watercolour painting, second to none in attractiveness. A collection of these eighteenth-century drawings, with their flat washes, calm lighting, logical composition and prevailing tones of grey-blue and grey-green is among the most pleasant adornment of any gallery or private collection. They have done much to form or confirm the quasi-idyllic impression of the eighteenth century as a halcyon age of Palladian architecture, elegant costume, courtly behaviour and orderliness. The great increase in the number of artists who now turned their attention to this branch of landscape painting is partly to be explained by the growth of public exhibitions of the works of living artists. The first such exhibition was held in England in 1760, and its success ensured new patronage for painters in all genres.

The late eighteenth-century watercolour painters of landscape may be divided into two main groups: the domestic and the Italian. The domestic group comprises on the whole those who did not travel in Europe, though there are exceptions to this; but the Italian group contains only artists who went to Italy and caught a reflex of Italian scenery and Italian style at first hand. Where there is such a galaxy of equal talent, omissions are difficult and unfair. The charming completeness of the 'domestic group' may, however, be adequately illustrated by the work of Michael Angelo Rooker, Thomas Hearne, Edward Dayes and Thomas Malton, junior.

Michael Angelo Rooker started life as plain Michael Rooker, the son of an accomplished engraver; but the nickname 'Angelo' stuck to him and is now part of his accepted name. As a topographical engraver his father had made plates from drawings by Paul Sandby and, whether through this connection, or in another way, the younger Michael Rooker became a pupil of Sandby's. He begins to emerge as a student of art and an exhibitor of drawings shortly before 1770. His father's connection with the stage – he was principal Harlequin at Drury Lane – had enabled him to get employment for Michael Rooker as a scene-painter at the Haymarket Theatre. He is thus one of that interesting group, including de Loutherbourg, David Cox and David Roberts, who found that the broad effects required in stage scenery were no hindrance to the composition of watercolours on a small scale and with ample detail.

In his choice of locale for his drawings he chose by preference country houses and provincial towns, places which even in his own day were thought sleepy and slow. He liked the mellowness of red brick and the play of sunlight upon it, and lingered with equal content on the details of the quiet town life or the green leafiness of the country. He had the taste of his age for ruins (Fig.6), but no predilection for ruggedness or stark grandeur. His well-known watercolour *Bury St Edmunds: the Norman Tower* in the Victoria and Albert Museum is justly one of his most famous works and approaches perfection as a ripe record of an agricultural town almost unchanging in its maturity. In Rooker's drawings are traces of the Dutch taste and of Canaletto, but no discernible Italian influence.

Thomas Hearne may be classified with the domestic group because of his obvious affinity of feeling and technique with Rooker, but he did at least have one journey overseas when he went to the Leeward Islands as draughtsman to the Governor. His employer, Sir Ralph Payne, was

7 Thomas Hearne
The Court House and
Guard House in the town
of St John's, Antigua

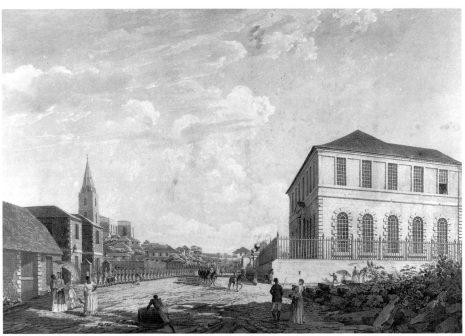

8 John Webber
View on Krakatoa Island,
near the Straits of Sunda

9 Thomas Daniell *Ruins of the Palace of Madura*

not conspicuous for the liberal nature of his views. He designed a pair of golden tongs to hold any letter or parcel handed to him by a native servant. The effect of his edict that the black servants should not wear shoes or stockings, but have their legs rubbed daily with butter so that they shone like jet, can be seen in the foreground figures, one rolling a barrel of sugar, in Hearne's watercolour *The Court House, St John's Antigua* (Fig.7).

Such exotic experiences were among the attractive adventures which might befall the budding draughtsman in that age of colonial expansion. John Webber accompanied Captain Cook on his third voyage to the South Seas from 1776. He witnessed his captain's death at Hawaii in 1779 and made a number of later watercolours of the sights he had visited (Fig.8). Thomas Daniell went to India with his nephew William, spending the years from 1785 till 1796 preparing for a monumental series of engravings, *Oriental Scenery* (Fig.9). George Chinnery, having followed them in India, spent the last years of his long life in Macao (Fig.10). But travel of this kind did not usually affect the voyager's style in the way that a visit to Italy could, by direct precept and the company of other artists; and in fact Hearne's style is even more precise and unperturbed than Rooker's. He was born a year or two before Rooker, emerged into public notice about 1765, and after his foreign

10 George Chinnery *A River Scene*

voyage settled down to a long life of drawing the places of interest in Great Britain, many for a well-known publication called *Antiquities of Great Britain*, to which he was still contributing as late as 1807. Hearne had not so forceful a sense of colour as Rooker, but he had almost fanatically good taste, and his work never falls below a consistently high level. His style represents the eighteenth-century formula at its most delightful, like Augustan prose or heroic couplets. It is hardly surprising that he was a favourite artist with Richard Payne Knight and Sir George Beaumont, who were the somewhat conservative arbiters of late-eighteenth-century taste.

The style of Canaletto is fully anglicized in the drawings of the two sons of Thomas Malton, who were Thomas Malton, junior, and James Malton. The father lectured on perspective, and his son Thomas taught Turner that subject. Turner himself became Professor of Perspective at the Royal Academy. The Maltons were architectural draughtsmen, but figures and incidents play an equally prominent part as the architecture in their drawings and are welded together with it into a picture which perfectly renders the town scene of the last quarter of the eighteenth century. Towns with a specifically Georgian interest such as Dublin and Bath, no less than London, were

16

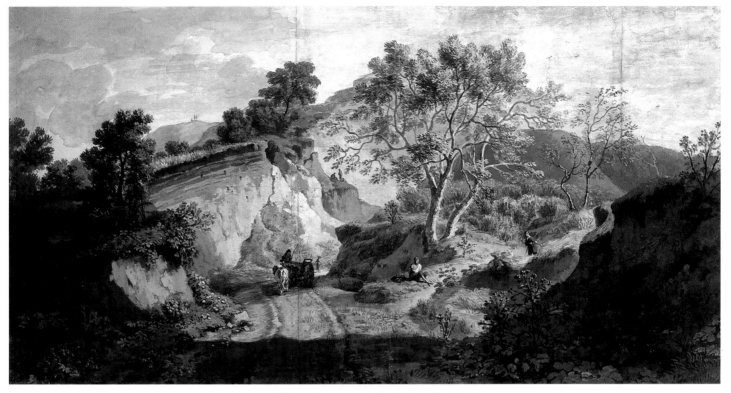

1 **William Taverner** *A Sandpit at Woolwich*

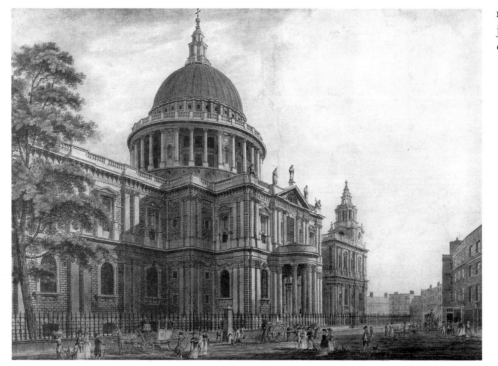

11 Thomas Malton, junior *The North Front of St Paul's*

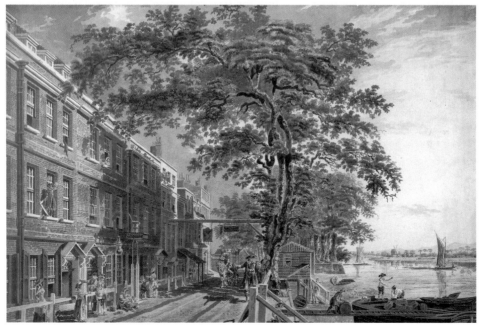

13 James Miller *Cheyne Walk, Chelsea*

their favourite subjects, and it is interesting to note that they preferred to draw the classical architecture of the seventeenth and eighteenth centuries, in contrast to the almost exclusive interest of many of their contemporaries in the antiquarian, the Gothic or the picturesque (Fig.11).

Another painter of this domestic group is Edward Dayes whose work begins in the 'eighties of the eighteenth century. His distraught and inequable temperament led him to take his own life at the age of forty-one, and his drawings are uneven in quality, but at his best he is very good indeed. Girtin was his pupil, and the early styles of both Turner and Girtin start off from his. Indeed, the connection is so close that it is sometimes hard to tell whether a particular drawing is in fact an early work by Turner or Dayes. The dependence of these greater names on him sometimes leads to Dayes being regarded merely as a teacher; but he deserves recognition in his own right as the author of some of the finest drawings of the last years of the century. He was an ambitious and skilled figure painter, fully alive to the colour and elegance of what was, in costume, a most graceful epoch (Fig.12).

How rich these decades were in draughtsmen of the highest class is further exemplified by the topographical drawings of James Miller (Fig.13), of whom all that is known is that he exhibited views of London and its neighbourhood from 1773 to 1791. His watercolours are assured in drawing, rich in colour, and redolent of the leafy greenness which were to be found even in a metropolis at that time.

Richard Wilson, the foremost British landscape painter in oils in the middle years of the eighteenth century, did not approve of watercolour. Thomas Jones recorded that he taught his pupils to make drawings with black and white chalk on toned paper. He thought that tinted drawings 'hurt the

15 **James Gillray** *Cymon and Iphegenia*

Eye for fine colouring'. Perhaps Thomas Gainsborough felt similar fears, since the greater proportion of his landscape drawings are made in monochrome on a coloured ground. But when he did employ watercolour the effect is to enhance the poetical feeling of his compositions (Fig.14). Although often drawn in his studio by candlelight from mosses, twigs, lumps of coal, mirrors and similar materials they have a truth of sentiment which is as moving as truth to Nature. As much as his oil landscapes, his drawings justify Constable's eulogy: 'On looking at them, we find tears in our eyes, and know not why'.

Thomas Rowlandson had no inhibitions either about method or subject-matter. He signals the appearance among the watercolourists of the satirists of the late eighteenth century, of whom Gillray is, beside Rowlandson himself, the best known.

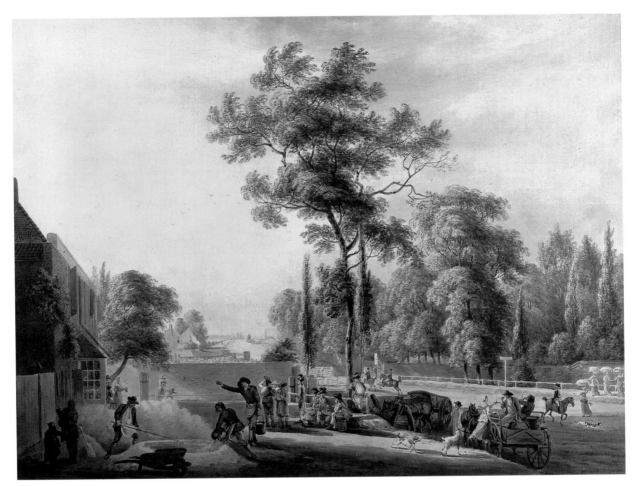

4 Paul Sandby *Morning: View on the Road near Bayswater Turnpike*

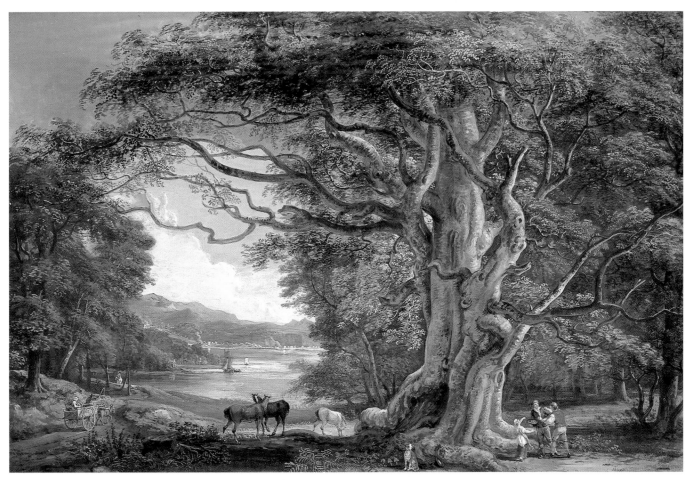

5 **Paul Sandby** *An Ancient Beech Tree*

Gillray did have his more genial moments, as his richly comical *Cymon and Iphegenia* reveals (Fig.15). But he was usually a savage political foe. The most bitter satire, sparing neither Royalty, sex nor ministers of State, was at this time disseminated by engraving and took in its stride the comedy of manners. To these ephemeral outpourings Rowlandson contributed as much with drawings as by designs for the engravers. Such was his facility that he found no difficulty in repeating his drawings swiftly, often with deft alterations; and he even manufactured duplicates by a process of damping paper and laying it over the outlines of a master drawing.

He had two manners, a slapdash, unreflective one, and a 'swell' one; and when he was disposed to concentrate he could produce drawings of great excellence in a manner quite distinct from that of the contemporary topographical watercolourists. Rowlandson's whole appeal rests in the outline of his drawing. His colouring is often perfunctory or unpleasing, and resembles the washes put over hand-coloured engravings. But it is in the line that he displays his great vitality, his overpowering gusto and joy in life. In that line we may see an echo of the Italian draughtsmen, such as Canaletto, just as in his subject matter we see a continuation of the type of humour which was Hogarth's specific contribution to English art. By reason of his immense range, Rowlandson is invaluable to the social historian; there is scarcely any side of the many-faceted life of his time of which he did not give a characteristically distorted impression in his own terms.

If we wish to savour the atmosphere of the pleasure gardens of Vauxhall when popular entertainers were performing to the most fashionable society we can sense it from Rowlandson's *Vauxhall Gardens*, exhibited at the Royal Academy in 1784 (Fig.16). Or if we are curious about the appearance of Spring Gardens, an address which became so well known for its exhibitions of the Society of Artists, its neighbourhood and its clientèle are acutely observed in Rowlandson's *The Mall, Spring Gardens* (Fig.17). His art usually verges on caricature, not always of the most refined kind. Yet at times he surprises us by supplying a sympathetic, though entirely personal and idiosyncratic view of the countryside. As a friend of the banker Matthew Michel he was a frequent visitor to Cornwall and he made many drawings of the scenery around his house near Bodmin (Fig.18).

The second important group of watercolour draughtsmen in the eighteenth century comprised those who broadened their knowledge of art and scenery by making the journey to Italy. As has already been made plain, foreign influence in English art was no novelty. It came through the collections of connoisseurs, and through the dissemination of prints.

A number of artists came to England, bringing with them the methods of painting current in Italy or Switzerland. The Florentine Francesco Zuccarelli was so much admired that he became a foundation member of the Royal Academy. His landscapes are decorative, in sharp contrast to his English contemporaries who were attempting to render the truth of natural appearances. He is therefore one of the eighteenth-century artists castigated by John Constable as a mannerist who 'strayed into the vacant fields of idealism' (Fig.19). Philip James de Loutherbourg was trained in Germany and France before settling in England in 1771. He had a considerable success with his stage designs and his sense of the theatrical is carried over into his watercolours of picturesque scenery (Fig.20).

However, the acquisition by British painters of a knowledge of foreign art by seeking it out abroad was a comparatively rare occurrence before

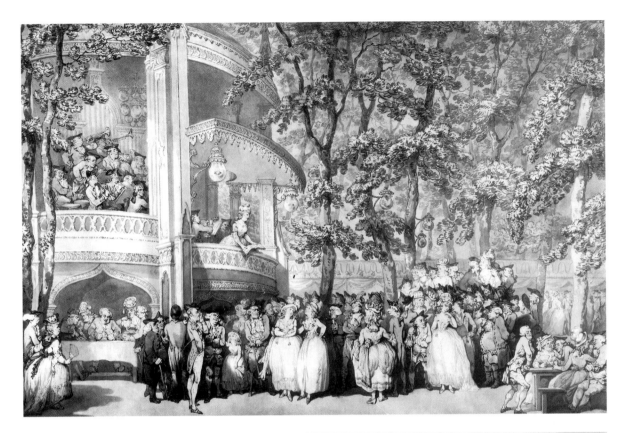

16 Thomas Rowlandson
Vauxhall Gardens

18 Thomas Rowlandson
Bodmin Moor

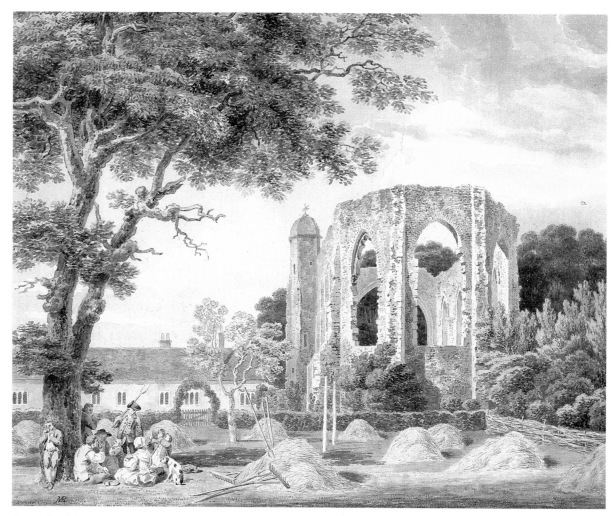

6 Michael 'Angelo' Rooker *Chapel of the Greyfriars Monastery, Winchester*

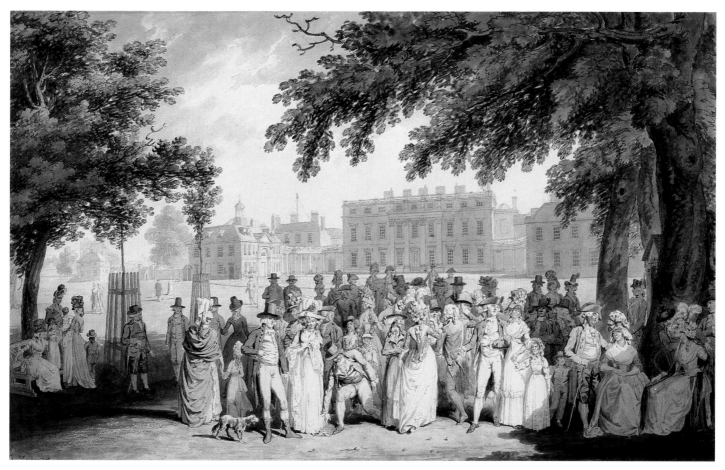

12 Edward Dayes *Buckingham House, St James's Park*

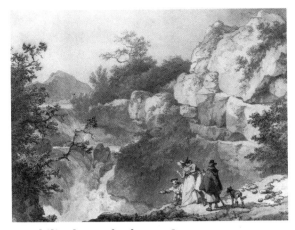

20 **Philip de Loutherbourg** *Cateract on the Llugwy, near Conway*

the middle of the century. Hogarth, in his xenophobia, deliberately eschewed any such contacts. Sir Joshua Reynolds, whose visit to Italy dates from 1749, and Richard Wilson, who followed in 1750, were two of the earliest eighteenth-century English artists to set out for Italy in search of self-improvement. Even so, few watercolour draughtsmen at this time made the journey on their own initiative. Most of those who did go went as draughtsmen in the retinue of some wealthy man making the Grand Tour or as the emissary of an antiquarian society.

One of the earliest and one of the best was J. Skelton (Fig.21), who has only recently been rescued from oblivion, and who arrived in Rome at the end of 1757. William Pars went to Greece as a draughtsman for the Society of Dilettanti in 1764-6, to Switzerland in 1771, and was later in Rome where he died in 1782. Pars was able to arouse interest in comparatively flat and featureless landscape – a kind of excellence which we find in the next century in De Wint – and is at the same time one of the first of English draughtsmen to respond in the Romantic manner to the Swiss and Alpine mountain scenery. His real feeling for

the drama of ruins, whether Classical or Gothic, is apparent alike in the drawings he made of Greece or Rome (Fig.22) or at home, and that feeling was skilfully carried over by Sandby in the aquatints he made after Pars's Greek drawings.

John 'Warwick' Smith has long been supposed to owe his nickname to the circumstance of his patronage by Lord Warwick, though it may come from his birthplace near the village of Warwick in Cumberland. He was in Rome from 1777 to 1781 and again in 1783. He shows the marks of his travel by an interest in Italian methods of composing landscape and in an enhanced sense of colour (Fig.23).

There are glimpses of some of these expatriate artists in the diary in which Thomas Jones recorded his life in Italy from 1776 till 1783. Jones himself was something of a pioneer in developing the open-air sketch, in which the immediate view from a window or balcony is the subject, rather than a carefully chosen place of natural beauty (Fig.24). He made many sketching expeditions with William Pars and John 'Warwick' Smith, as well as with J.R. Cozens and Francis Towne. On one of these excursions near Naples Jones had just remarked that it only needed some bandits to make the scene a perfect picture by Salvator Rosa when he and Towne turned the corner to be confronted by three ugly-looking *Sbirri* cutting up a dead ass. Towne immediately retreated, saying that he relished such scenes in a painting but not in Nature.

As might be expected from this anecdote, Francis Towne lived a retired life, sold few of his drawings, and was almost forgotten till the researches of the present century resurrected him as a man of unusual but definite greatness. It was his journey through Switzerland to Italy which gave his style its distinction both by the overwhelming effect of the Alps upon his fantasy

and the lessons he learned on how to express their effect. His mode of drawing, marked by a strong pen outline filled in with flat colour washes, owes a great deal to the Swiss topographical prints; indeed, sometimes those drawings are like enlargements of a section of a Swiss print of a glacier or mountain massif. But whatever its origin his style has a force which is particularly fitted for appreciation today, with its elimination of details and inessentials, and its concentration on the main structure of confessedly moving scenery (Figs 25, 26). He did not confine himself to Swiss and Italian scenes, but also drew panoramic views of the Devonshire scenery amid which he was

born; and like so many others of his and subsequent generations he sought, not unsuccessfully, to find in the English Lake District a little Alps.

John Robert Cozens is an artist whose accomplishment, springing though it does from the body of work already considered, absolutely outstrips it, and makes him one of the greatest European artists in any medium. His career and style are so bound up with those of his father, Alexander Cozens, and his patron, William Beckford, that it is necessary to prefix some words about these two interesting men to an account of John Robert Cozens.

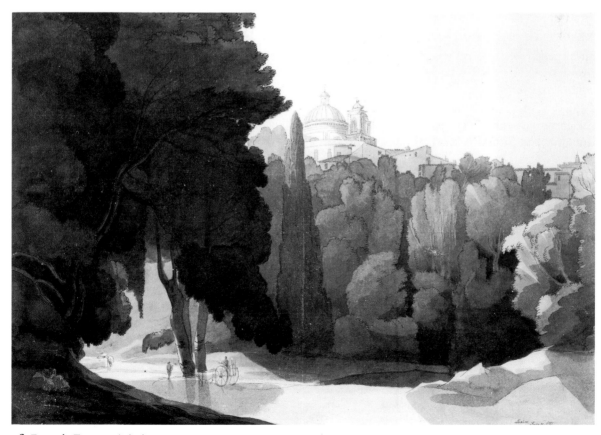

26 Francis Towne *Ariccia*

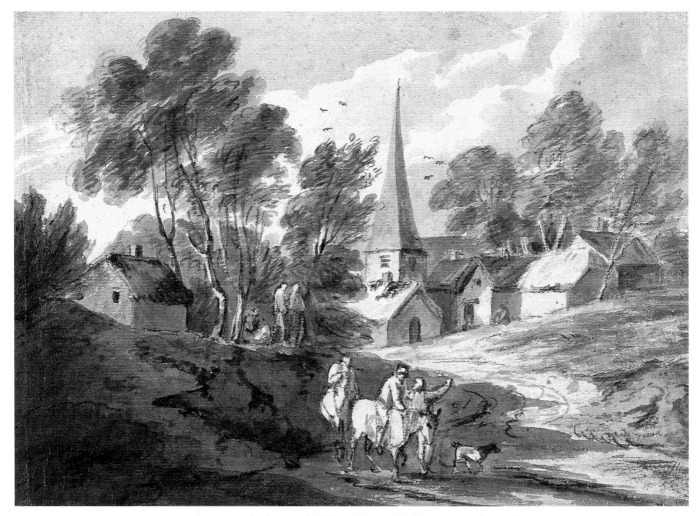

14 Thomas Gainsborough *Village Scene with Horsemen and Travellers*

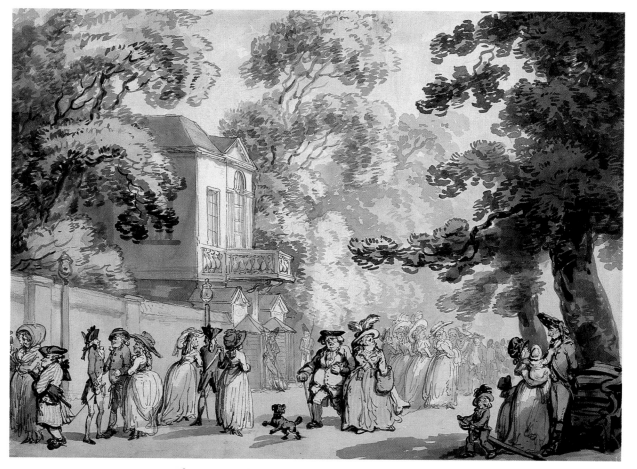

17 **Thomas Rowlandson** *Entrance to the Mall, Spring Gardens*

Alexander Cozens was born, presumably of English parents, in Russia, and brought with him from the East of Europe a knowledge of Oriental art and probably more occult learning besides. He was in Rome in 1746 and became a fashionable teacher of drawing in England in the 1750s. When William Beckford, son of the millionaire Lord Mayor of London, required tutors regardless of expense, Mozart was chosen to instruct him in music and Alexander Cozens in drawing. A warm friendship sprang up between the teacher and the pupil. Cozens implanted in him his fondness for Oriental studies – an impulse which later bore fruit in Beckford's remarkable romance of Vathek. He is also suspected, with no little probability, of having initiated Beckford into dabbling with black magic.

England was then at the threshold of the Romantic Revival. A generation or more before Wordsworth, Keats and Shelley, it was becoming the custom to give the freest rein to the expression of emotion. Scenery of the sort painted by Claude and Salvator Rosa was recognized as the prime source of those feelings of ecstasy, wonder, or awe, which were valued in proportion to their intensity. Beckford, who was born to extreme riches, and gifted with an especially sensitive nature, deliberately cultivated his sensibility to the utmost. His drawing master, Alexander Cozens, combined a similarly enthusiastic temperament with the eighteenth century's fondness for systems. One of his systems, which brought him equally renown and execration, was a method of helping the artistic fantasy in the composition of ideal landscape by a sort of rapid doodling with blots. His own drawings, whether suggested by this method of free association or by direct abstraction from nature, emphasize his fondness for rugged, mountainous scenes, and are executed in a subtle scheme of blacks and greys. For once it is probably not misguided to compare them to Chinese or Japanese landscape painting, for he may well have seen such originals in his travels.

Alexander Cozens endowed his son John Robert Cozens with more than all his imagination and all his executive skill; and by applying these gifts to the scenery he saw on his visits to Switzerland and Italy the son entered the front ranks of creative art. The second of those visits was made as part of the train of William Beckford, and what the artist created was fully in accord with the romantic intentions of his patron but controlled and moulded into the intensity of art. The means he employs are of the simplest. They are far more akin to the nuanced monochromes of Claude than the polychromatic drawings of Sandby and Rooker. J.R. Cozens uses tones of blue-grey, a yellow or more definite tint, but makes no attempt at local truth of colour. Atmosphere and form are what he aims to interpret, and he succeeds magnificently in that endeavour. Whether it is the view from the terrace of the Villa d'Este across the level fields of the Campagna, or the sublimity of the inhospitable mountains whose craggy summits are lost in mist, Cozens conveys the fullness of his response. He is a great and universal artist, because in those drawings he is perfectly expressing the feelings of an age, purged of all their fashionable dross and in their naked impressiveness. Claude has helped to point the way, and he is neither forgotten nor slavishly followed, but assimilated in J.R. Cozens's evanescent misty atmospheres, just as the way shown by Salvator Rosa is assimilated in Cozens's comprehension of the terrifying solitudes of great mountains. He is so much more than a topographer. When John 'Warwick' Smith draws a mountainous scene which is picturesque or even impressive, his is the report of a somewhat unimaginative traveller passing through such scenes. But Cozens felt the

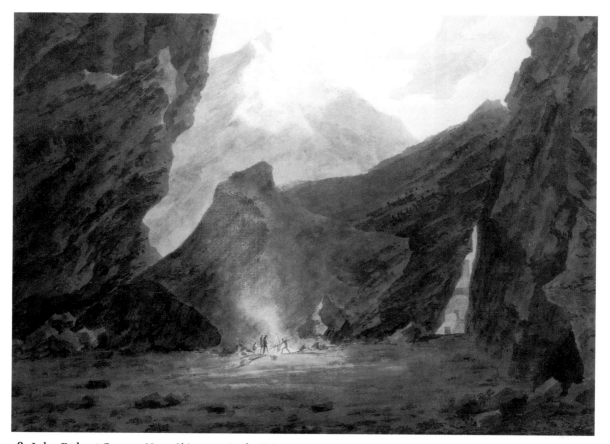

28 **John Robert Cozens** *Near Chiavenna in the Grisons*

mountains, as he felt the plains, with all that awakened intensity, the sense of a new emotion, which great scenery gave to the recently opened eyes of the impressionable eighteenth-century traveller; and aided by the formal language which his father had discovered, and spurred on by Beckford's own enthusiasm, burning at fever heat, he immortalised those sensations and those visions of the romantic traveller (Fig.27). In his vision of Nature the human being is dwarfed by the hills, as in *Near Chiavenna in the Grisons* (Fig.28) or by immense and inaccessible barriers erected by man, as in *The Castle of St. Elmo, Naples* (Fig.29).

John Robert Cozens lost his reason three years before his life ended at the age of forty-five. But although he did not come much into personal contact with the next generation of watercolourists his greatness did not stay unfruitfully embedded in his own works and their relatively few collectors. His drawings were given to Turner and Girtin to copy and thus provided a starting point for the next achievements of the English watercolour school.

19 **Francesco Zuccarelli** *Market Women and Cattle*

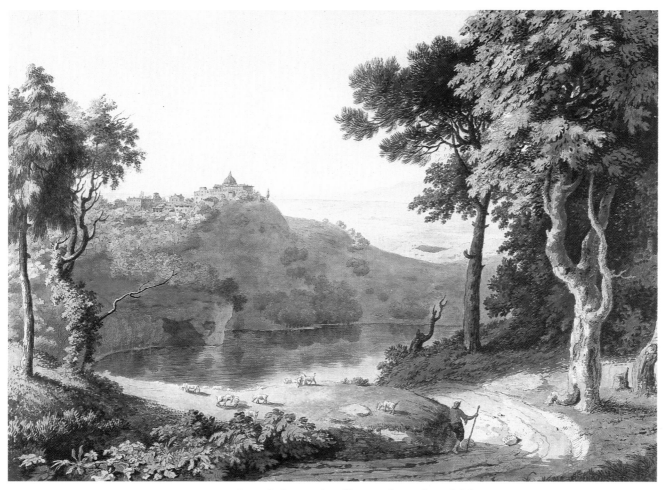

21 Jonathan Skelton *Lake Albano and Castel Gandolpho*

30 Robert Dighton *A Windy Day – Scene outside the Shop of Bowles, the Printseller, in St Paul's Churchyard*

In the formative years of the English tradition watercolour was more extensively employed upon landscape. But some eighteenth-century artists used the medium for figural composition. In particular the all-pervasive prevalence of satire in both literature and art ensured that dissenting voices would also be heard amongst the watercolourists. They frequently supplied coloured drawings for the engravers. The method by which these were brought to the attention of the London public is amusingly portrayed in Robert Dighton's scene outside the shop of Bowles the Printseller (Fig. 30). One of the many artists who supplied material for the printmakers was John Collet. On the evidence of such drawings as *The Asylum for the Deaf* (Fig. 31), long attributed to him, he is credited with having 'plagiarised Hogarth, but missed his deep moral'. Certainly this lively group of itinerant musicians and beggars is closely modelled on Hogarth's satires of London street life.

Similar modes of satirical observation were continued into the nineteenth century by Edward Francis Burney in such crowded and exuberant compositions as *The Waltz* (Fig. 32). It conveys the impression of licentious abandon felt when the dance was first introduced, satirized by Byron in 1812:

Round all the confines of the yielded waist
The strangest hand may wander undisplaced
The lady's in return may grasp as much
As princely paunches offer to her touch

For other artists caricature was an occasional alternative to their more usual interests. Samuel Hieronymus Grimm was born in Switzerland, a child of the *Sturm und Drang* movement. After settling in England in 1768 he found substantial occupation amongst patrons anxious for antiquarian or topographical drawings, amongst them Gilbert White of Selbourne (Fig. 33). But he too felt impelled to cast a critical eye on the excesses of contemporary fashion, and his *The Macaroni* (Fig. 34) could pass as a direct caricature of Richard Cosway, the foppish but monkey-like miniaturist.

Other artists selected more elevated themes which might profit from the veneration felt for the higher ranges of art in academic circles. Samuel Shelley is now remembered only as a miniature painter of slightly lesser renown than Richard Cosway; however, a substantial proportion of his exhibits at the Royal Academy were 'fancy figure subjects' in watercolour. He filled many

31 John Collet
The Asylum for the Deaf

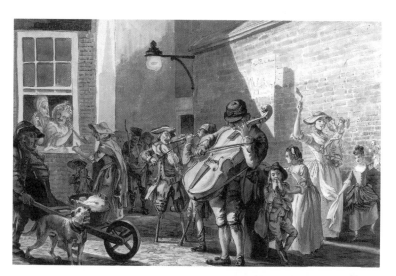

32 Edward Francis Burney
The Waltz

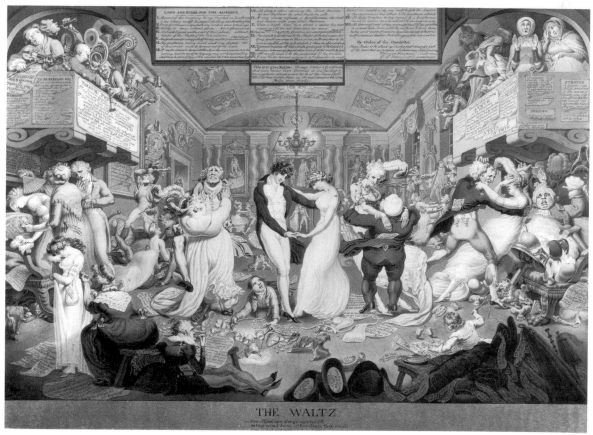

22 **William Pars** *A view of Rome taken from the Pincio*

23 **John 'Warwick' Smith** *Stonework in the Colosseum*

33 Samuel Hieronymus Grimm *Mother Ludlam's Hole, near Farnham, Surrey*

sketchbooks with designs illustrating a wide range of literature including Homer, Anacreon, Tasso, Goldsmith, and Goethe. The contemporary romance, in the form of Johnson's *Rasselas*, provided him with the theme of the Prince of Abyssinia, his sister and others 'conversing in their summer rooms on the banks of the Nile' (Fig.35). It was the reluctance of the Academy to give due weight to such performances, and his feeling that watercolour painters were unfairly discriminated against, which led Shelley to play an active part in the formation of the exhibiting Society of Painters in Water-Colours in 1804.

The importance of this body, under its more usual name of the 'Old' Watercolour Society, in shaping the course of the medium will become apparent in what follows.

Richard Westall's choice of themes was also closely linked to the requirements of book illustration. His sources included Shakespeare, the Bible and Thomson's *The Seasons*, and *Rosebud, or the Judgement of Paris* (Fig.36) with figures dressed in a fanciful reconstruction of historical costume illustrates a poem by Matthew Prior. J.C. Ibbetson, whose subjects included the humours of sailors on shore leave and a reconstruction of

35 Samuel Shelley *Rasselas and his sister* ▷

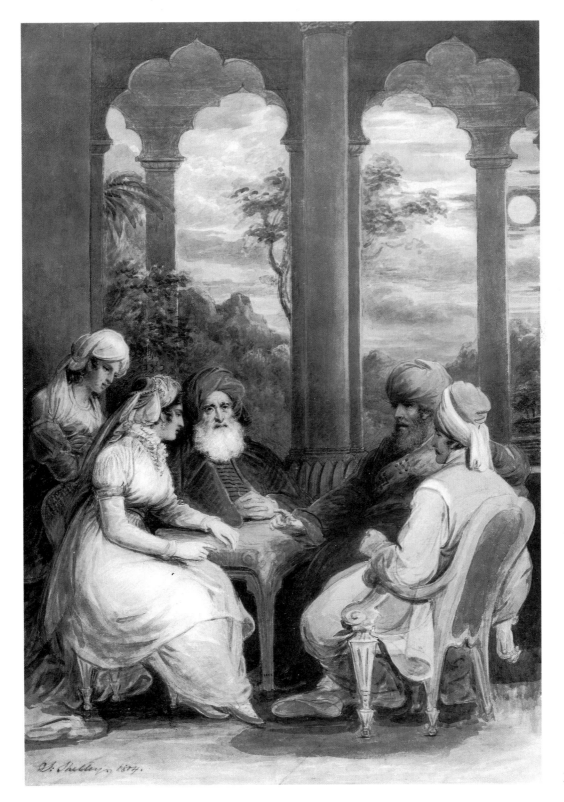

S. Shelley, 1807.

39

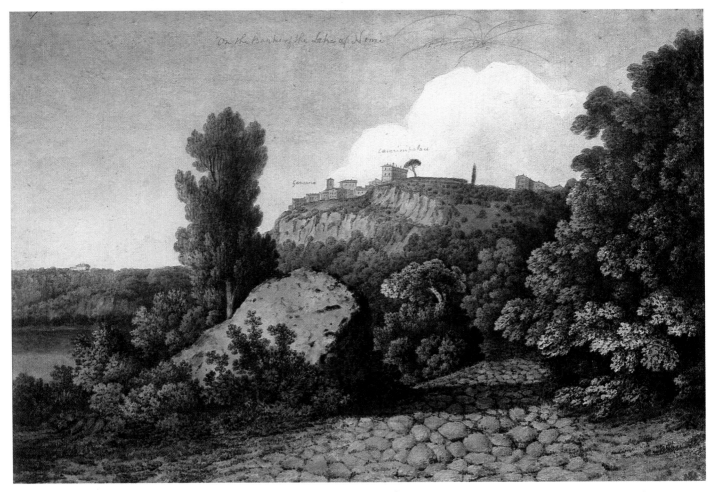

24 **Thomas Jones** *Lake Nemi*

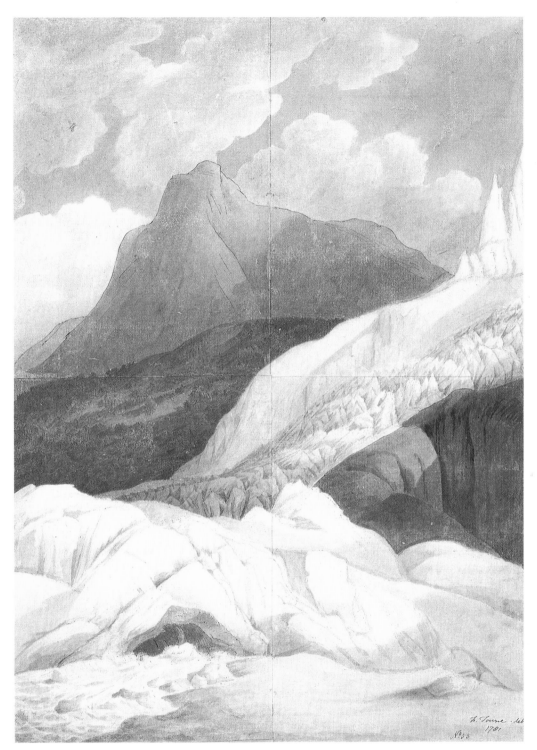

25 Francis Towne *The Source of the Arveiron*

36 Richard Westall *Rosebud, or the Judgement of Paris*

the scene at Captain Cook's death, achieved a more up-to-date embodiment of late-eighteenth-century sentiment in *The Sale of the Pet Lamb* (Fig. 37).

The artist who tried hardest to recapture the terribilità of the tragic style, in his drawings as well as in his paintings, was Henry Fuseli. Whilst his drawings of women with fantastic coiffures exude a disturbing eroticism, his scenes from

the Eddas and the drama are conceived in the Grand Manner appropriate to the highest type of art. *Œdipus cursing his son Polynices* illustrates a scene in Sophocles' *Œdipus Coloneus* (Fig. 38). Polynices has come to beg for his father's blessing in his war against Thebes, but Œdipus repulses him as a hypocrite and turns him out as a beggar:

Go to ruin, spurned and disowned by me

37 Julius Caesar Ibbetson *The Sale of the Pet Lamb*

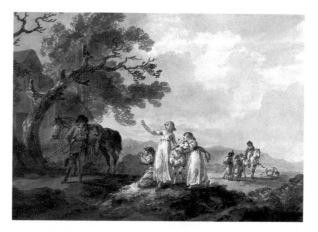

38 Henry Fuseli *Oedipus cursing his son Polynices*

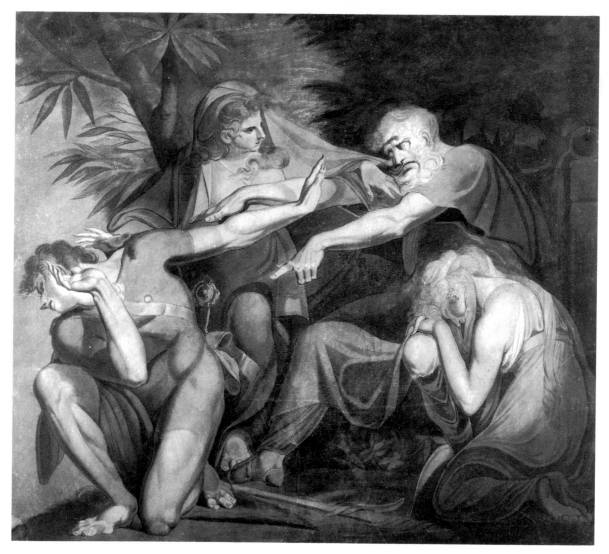

27 **John Robert Cozens** *Mountains in the Isle of Elba*

29 John Robert Cozens *The Castle of St Elmo, Naples*

2 The early nineteenth century *Girtin, Turner, Cotman, Cox, De Wint, Constable, Bonington, and the Exhibiting Societies*

ALREADY, by the time of Cozens's death in 1797, a great number of new artists were coming to the fore, who in their fertility, variety and originality were to add greatly to the lustre of the English school of watercolour painting.

The first important newcomer after J.R. Cozens is Thomas Girtin. He was born in 1775, the same year as J.M.W. Turner, and received his artistic education from Edward Dayes. The drawing of Dayes at its best is the culmination of that type of eighteenth-century drawing, of Dutch origin, in which attention is paid to the rendering of local colour and of which the keynote is neatness of architectural draughtsmanship and elegance of fashionable figure drawing. The early work of Thomas Girtin fits right into this tradition and shows how ably he imbibed his master's instruction. It is irrelevant to the present purpose to record how Dayes is said to have quarrelled with his clever apprentice because he was jealous of his rapid mastery; how he is said to have put Girtin in prison, and after Girtin's early death to have cast aspersions on his moral character in the short biographical notice which he wrote on him. What is relevant is that Dayes transmitted to Girtin a craftsmanship of a very high order; but it was not in the manner or idiom he learned from his master that Girtin made his original contribution to the development of watercolour drawing and fashioned his own finest drawing.

After leaving Dayes, Girtin found the customary occupation for one of his profession and accompanied an antiquary, James Moore, on a tour of the picturesque scenes and ruins of Scotland and Wales in the capacity of draughtsman. This period of his career coincides with a rather harsh transition in his style; we may call it his 'cold' period, for the foregrounds of drawings of this time are grey and the background blue, and the tones do not blend warmly. He was also to come under the influence of Cozens through an unofficial institution important in the history of English watercolour and known as the 'Monro School'. Dr Monro was the doctor who attended Cozens in his mental illness, and he was a keen amateur of the English watercolourists. He had a number of drawings by Cozens, and he encouraged young artists to come to his house in the Adelphi in the evening to copy these and other drawings, for the fee of two shillings and sixpence per night. By far the most celebrated of the copyists who came to Dr Monro were Girtin and Turner. It used to be supposed that the Doctor instituted his system out of sheer benevolence to the young artists, and designed it to improve their styles. The truth seems to be, however, that he set them principally to copy drawings in the possession of other collectors simply because he wanted replicas of them for his own collection. To meet his requirements a sort of mass production was organized whereby one artist made the pencil

outlines, another put in the first tint, and so on, until the copy was completed. Be that as it may, the effect of the 'Monro School' was to place before Girtin, and before Turner, the masterpieces of Cozens's Italian travels, and it is only necessary to look at their maturer work to learn how they profited from this opportunity. Another source for the enrichment of Girtin's style was his personal taste for the more spirited Italian draughtsmen of the eighteenth century. He copied architectural subjects and fantasies from Canaletto, Marco Ricci and Piranesi, and the mark of this admiration is to be found in the vitality of his line, the vivid calligraphy of his outlines, as much as in his mastery of composition.

There were two main trends in the watercolour landscape of the early English school. One branch aimed at an approximation to local colour: Girtin's early work under the tutelage of Dayes falls into this category. The other branch of eighteenth-century English drawing follows the longer-established tradition of monochrome drawing, though no longer remaining monochrome itself. The effect of the drawing as a representation of nature is brought about in this case by the contrast of tones within a fairly restricted gamut of colours. Cozens, up till this time the greatest exemplar of the latter category, evoked the whole majesty and mass of Alpine scenery in varying tones of blue tempered with grey; he composes as it were in the key of grey-blue. Girtin in his mature style practises drawing in this same sense; and

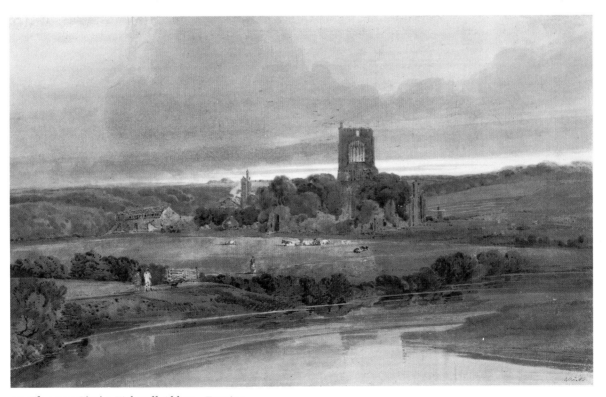

39 Thomas Girtin *Kirkstall Abbey – Evening*

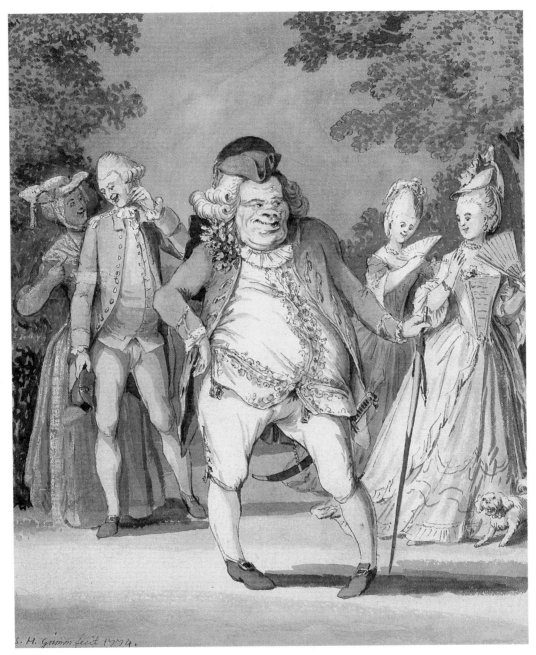

34 Samuel Hieronymus Grimm *The Macaroni*

grey forms an important undertone in his colour scheme as a necessary bond between the colours he uses. But in place of the cold grey-blue of Cozens he composes in a warmer key of grey or brownish grey. The difference in tonality accurately reflects the gulf between the melancholy and unstable imagination of J.R. Cozens and the warm, sanguine temperament of young Girtin.

Girtin did not often draw mountainous scenery, but in his drawings of ruins he arranges the composition so that the buildings tower mountainously above the draughtsman, or, as in *Kirkstall Abbey* (Fig.39), are seen with the evening light falling through the broken tracery. The details of his handling equally show his loving regard for the crumbling surface of old stone or brickwork: the brush flickers here and there, rounding off what once was square and giving the appearance of age to every nook and cranny in a wall. In less antiquarian mood he delighted to draw rolling country. Occasionally a cloud in the manner of Salvator Rosa spirals upward from a flat landscape reminiscent of Koninck. These wide expanses, typical of the countryside he loved, are diversified by few features, but are spread out beautifully by his power of composition and the interesting play of his line (Fig.40). The same penchant for flat country is to be found in De Wint, who learned it from Girtin.

Girtin was also the first of a line of artists – Edridge, Prout, Bonington, Boys, Callow – who found a new topographical interest in drawing the streets of Paris. He went there in 1801, the year before his tragically early death at the age of twenty-seven, and in the drawings he made of the narrow streets with their vistas of buildings with regular façades is to be found the quintessence of Canaletto's teaching to the English draughtsman and the start of a new fashion in topography. All is accurate and fully realized in form, but it is free, of vigorous line, and in no way monotonous.

To treat of Turner after Girtin is inevitable. Their courses ran side by side in the 1790s, when indeed it might at one time have seemed that Girtin had the advantage over Turner, and chance added many resemblances to a friendly rivalry which closed only with Girtin's death in 1802. They were born in the same year and worked together in Dr Monro's house when they were each promising young men less than twenty years old. Indeed, so closely were they linked together in the minds of their contemporaries that when Farington was making a note in his diary about their common employment by Dr Monro, he condescended to record the egregious pun that Girtin's mother was a 'Turner' by trade!

As their biographies were parallel, so was the development of their style during its earliest phase: there are drawings of the period which have given plenty of scope for discussion on whether they are by the young Girtin or the young Turner. In the drawings produced for Dr Monro there is plentiful scope for confusion, particularly as Girtin is said to have made the outlines and Turner to have applied washes to them. But by 1795 or 1796 their ways diverge: each has acquired his distinct and original individuality. Turner was working somewhat in the manner of Hearne, Rooker, and Dayes; but before developing his more advanced and revolutionary styles he had raised the traditional eighteenth-century methods to new heights. The drawings of Gothic architecture which he exhibited at the Royal Academy in the 1790s are carried out in cool tones of yellowish green and greenish grey; but for all the exquisite precision of the rendering of architectural detail there is already a greatness of imaginative conception in the whole which makes them the best topographical antiquarian drawings as yet seen in the English school.

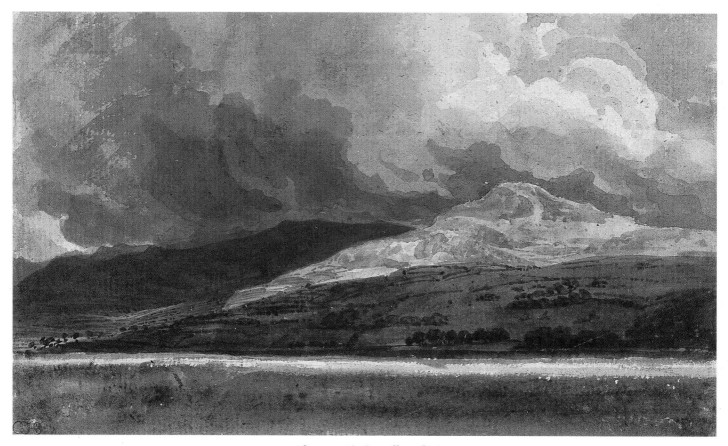

40 Thomas Girtin *Hills and River*

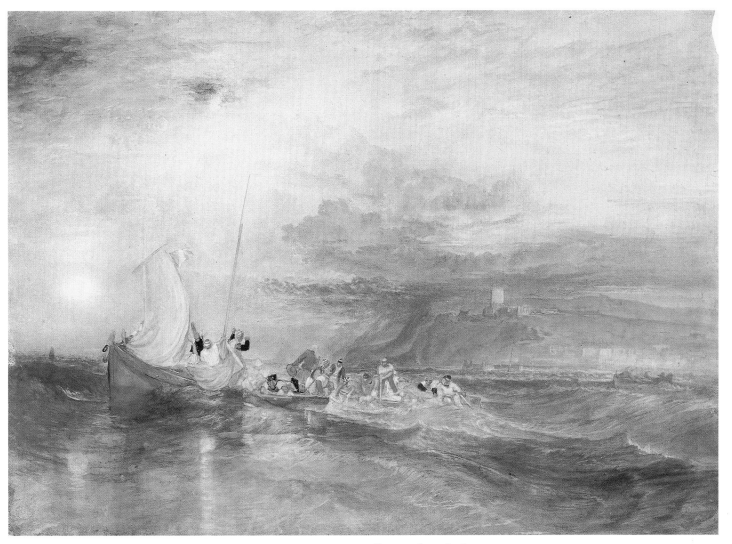

43 **J.M.W. Turner** *Folkestone from the Sea*

The comparison of similar careers is one of the most illuminating services criticism can offer, and so before Turner's life passes beyond the possibility of such a comparison it is well to refer to some of the essential differences between him and Girtin. Both Girtin and Turner have been hailed as great originators – indeed for a long time they were regarded as the primitives of English watercolour. The ground which has already been surveyed in Chapter One shows how little basis there is for such a claim. But it is true that each artist had immense originality and struck out a new path. What is not generally recognized is that Girtin went forward by stepping backward: he reverted to the method of drawing in tone which is the characteristic of the seventeenth century, of Claude and Rembrandt. He is the last protagonist of that method in English watercolour. Turner, on the other hand, took the method of the more colour-conscious eighteenth-century watercolourists and infused it with his own growing enthusiasm for pure colour and bright light. Neither style was preferable to the other, but the difference exists and should be comprehended; especially as in regard to colour it was the lead of Turner which was followed by Cotman, Cox and the succeeding masters of English watercolour.

One other essential difference emerges from the comparison of Girtin with Turner. Turner is, early and late, obsessed with the minutest detail. As Ruskin pointed out, there is no spot of colour in his work which is not modulated. In the drawings of his earliest phase, as in the styles which succeeded to it, he leaves no broad patches of which we can say 'the whole of that is one colour'. But he does not destroy the breadth in effect of his drawing by this concern with its parts. Girtin, on the other hand, as soon as he had emancipated himself from the tutelage of Dayes, did leave relatively immense areas of his

drawing stained with one uniform wash; and when he does get down to detail he draws it calligraphically, that is, impressionistically. And in this matter of breadth of washes many later exponents of watercolour – Cotman, Varley, De Wint – found it expedient to follow Girtin, whereas those who followed Turner were able to satisfy the Victorian taste for detail.

The second phase of Turner's watercolour style is one which is not generally so well recognized. It emerges in about the year 1800, and is characterized by a subdued harmony of colouring – yellowish brown rather than greenish grey in

41 **J.M.W. Turner** *The Old Road – Pass of St Gothard*

52

key – and shows in design evident marks of the study Turner was giving at this time to the works of Wilson in his efforts to master the science of composing his pictures.

Turner's first visit to the Continent in 1802, when he travelled in France and Switzerland, stirred him profoundly. The excitement which he felt in the presence of the sublimities of Alpine scenery is expressed in his sketch of the Pass of St Gothard. The constricted vertical composition and nearly monochrome washes convey the vertiginous terror of the pass (Fig.41).

After his first visit to Italy eighteen years

later, Turner set out on his return to England in January 1820. The Mont Cenis Pass was blocked by snow and the coach overturned at the summit, so that he and his party had to walk for the entire descent. He painted a record of this battle with the elements for his faithful patron, Walter Fawkes (Fig.42).

Advancing his oil painting and watercolour drawing in tandem, Turner proceeded to abandon his earlier inhibitions about the unrestrained use of colour. In this phase of his art he produced an amazing series of jewel-like, highly finished drawings in which the blues and reds glow with

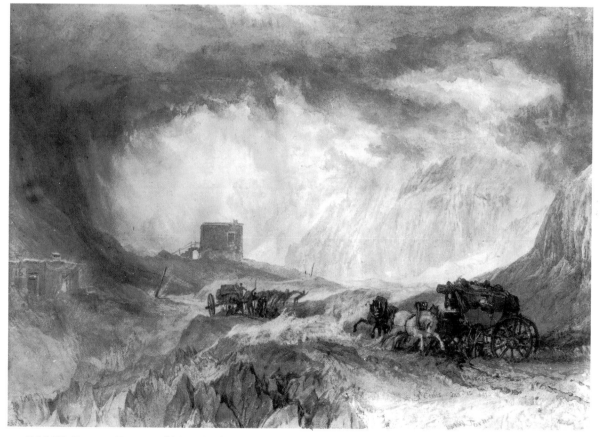

42 J.M.W. Turner *Passage of Mont Cenis: Snowstorm*

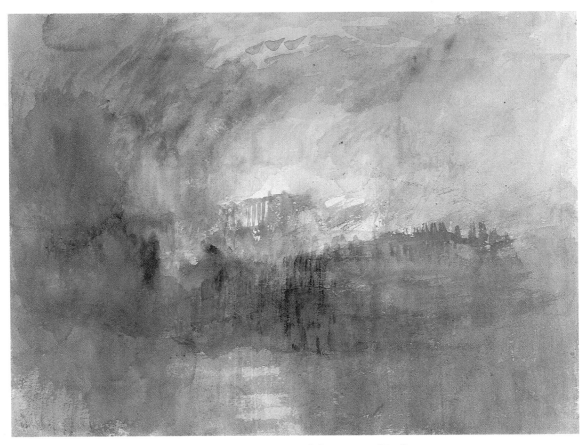

44 J.M.W. Turner *Burning of the Houses of Parliament*

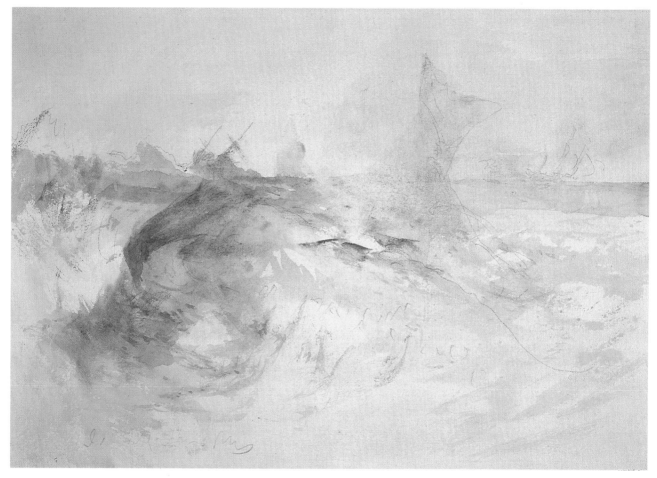

45 J.M.W. Turner *Looking out to Sea, Stranded Whale*

intense brilliance of light. These drawings, more than any, illustrate Turner's attention to minuteness of detail. The hillside and the sky are equally composed of a tapestry of varying colours to represent the effect of light reflected and refracted from them. Turner is obsessed with light and colour; but his instinctive memory and consciousness of form never desert him. Turner was the only member of the English watercolour school who, starting as a watercolourist, reached the highest distinction as an oil painter; in his work the two techniques interacted and each suggested developments in the other's sphere. It was no doubt his experience with oil paint and the possibility of minute graduations in it which led Turner to discard the broad washes of traditional watercolour for stipplings and hatchings in which the white paper peers through the dots of colour and achieves the greater brilliancy.

In these drawings he has left the paths of accurate or, as he thought, 'mere', topography for the more generalized approach. Now, when he drew Rouen or Folkestone (Fig.43) it was not a photographically exact copy of the scene before him, but a representation true to the *genius loci* combining salient and recognizable features with picturesque embellishments, the vehicles of the artist's own feeling. In addition to being a generalizer, Turner also aimed at the universal: in quest of the whole geographical truth, as it were, he made those frenzied tours down the Rhine and the Moselle, to Venice and Switzerland; he had to see everything, to make scanty sketches in the notebooks he always had in his hand, and from them to work up, by means of his amazing visual memory, and inexhaustible repertory of forms, this series of full-dress drawings. The drawings themselves were often intended for engraving, in books with such titles as *Picturesque Views on the Southern Coast, Picturesque Views in England and Wales, The Rivers of France*, and so on; and by his own personal supervision and instruction Turner trained a generation of engravers capable of rendering the nuance and tone of his most elaborate and subtle compositions.

Finally we come to the last phase of Turner's style, that rightly or wrongly called 'impressionistic', when his love of colour almost overcame his love of form and he seems to make abstract and, at first sight, unintelligible transcripts of the visible world. At first sight, because on close inspection there is seen to be both form and meaning in what he has drawn: he has caught the scene as it might flash upon the sight on a brilliant summer day. The interiors of Petworth are amongst the best-known examples of these later series, and there is something in the method which suits it better to the rendering of the intimacy of a domestic interior than a searching inquisition with a lens of perfectly adjusted focus. From the same period also come Turner's most resplendent views of Venice burning brightly beneath its revealing sun, and at this time too he delighted in delineating the Swiss valleys swimming in mist, with castles perched on inaccessible crags. Turner was then, as he had always been, a Romantic, and as happens with many great imaginative artists, the freedom of his Romanticism grew more unrestrained as he grew older.

The burning of the Houses of Parliament in 1834 provided him with an ideal subject. He was prone to represent scenes of disaster, and here was one happening before his own eyes. It was symbolic of the threat to the constitution, of which he had long been a prophet of doom. At the same time it was a magnificent display of red and yellow flame against a blue sky; a cosmic firework display which brought out all his skill in the watercolour sketches he made of it (Fig.44).

In the last years of his life he read Thomas Beale's *The Natural History of the Sperm Whale* and the shadowy shape of a whale is sometimes to be discerned in the almost abstract patterns of colour which constitute his latest studies of the coast (Fig.45).

The first years of the nineteenth century witnessed the emergence of an institution which organized most of the leading watercolour painters, canalized the available patronage, and acted as a strong formative influence on the future development of the English style. This institution was the Society of Painters in Water-Colours, known, to prevent confusion with similar rival bodies which were set up later, as the 'Old' Water-Colour Society. It was inaugurated in 1804 by a group of watercolour painters who were dissatisfied with the treatment accorded to their wares in the Royal Academy. They complained that their watercolours were hung alongside the inferior oil paintings on crowded walls and in a bad light; further, that the title of Royal Academician, by the rules of the Academy, would not be conferred on those who painted only in watercolours. They also had faith, which proved fully justified, in the prospective profits to be made from the rich patronage of the new merchant and nabob class.

So the Old Water-Colour Society was formed and held its first exhibition in 1805, with a membership of sixteen artists. The Society was never an open society: it kept to a small, closed number of exhibitors and replaced them by invitation. Apart from a setback due to the financial stress of the Napoleonic Wars it was uniformly prosperous, and it was fairly representative of English watercolour till about 1850, when the challenge of Pre-Raphaelitism found it, like many another established academic institution, not flexible enough in its ideas to meet a change of taste.

Although, or because, they had taken such pains to segregate watercolours from oil paintings, it was from the very beginning a tenet of the Society's that watercolours could vie with oils in depth and richness of colour and in brilliancy. Following the practice of the time, the drawings were exhibited framed, like oil paintings, with heavy gilt mouldings right up to their edges. It was not till after 1850 that the white mounts, which our modern taste prefers to set off watercolours, began to oust these heavy gilt frames from favour, and then only gradually.

In spite of the quite separable individuality of each of the members of the Old Water-Colour Society, a homogeneous style was to be discerned in its exhibitions. It was a style different in many ways from that of the eighteenth-century topographical draughtsman's, and equally different from Cozens or Turner. In composition the hand of Gaspard Poussin, Claude and the other seventeenth-century landscape painters lay far more heavily upon the work of this group. In colour, while the artists strive after richness and complexity, they have, in their competition with oil painting, often caught its deep tonality and its varnish brown. Sir George Beaumont's brown tree and old Cremona violin would not be out of place in the works of Glover or Barrett, Hills or Robson. The combined effect of dark tonality with formalized picturesque composition gives a certain heaviness to the productions of the early members of the Old Water-Colour Society which contrasts greatly with the lightness of Rooker, Pars and Hearne, to name but three of the predecessors whom they despised as old-fashioned makers of feebly-tinted drawings. But when due allowance has been made for the change of outlook many worthy draughtsmen are to be found in the lists of the Old Society, and the majority of enduring early nineteenth-century reputations

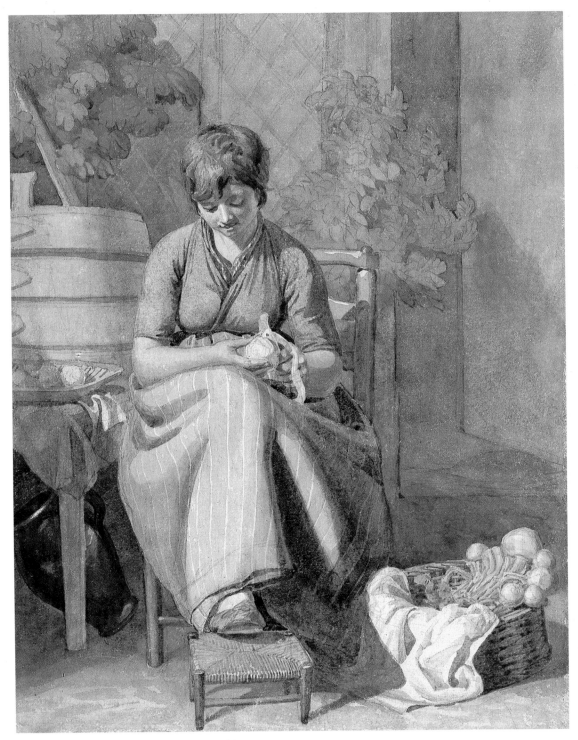

46 Joshua Cristall *A Girl Peeling Vegetables*

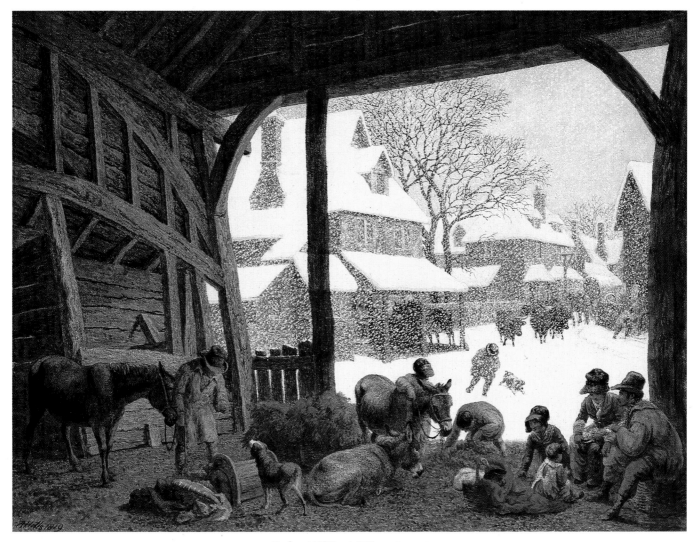

50 **Robert Hills** *A Village Snow Scene*

were made possible by the encouragement and recognition afforded through the Old Water-Colour Society – for instance, those of Varley, Cox and De Wint.

An artist senior to these among the founders of the Old Water-Colour Society was Joshua Cristall. He was approaching forty years of age when the Society was founded, and had lived a life of great hardship pervaded by the determination to practise art at all hazards. Subsequently he became President of the Society, but his career was never a prosperous one. Cristall was an accomplished draughtsman of the human figure. His work in this field ranges from sympathetically observed countryfolk (Fig.46) to elaborate compositions; the *Fishmarket on the Beach at Hastings* which he exhibited at the Old Water-Colour Society in 1808 (now in the Victoria and Albert Museum) is a complex arrangement of over thirty figures in a crowded but not confused composition. Some of his subject matter ran parallel to the poetic tastes of the Sketching Society of which he was a member, and he was one of the earlier British artists to allow his imagination to wander with classical shepherds in Arcadian fields (Fig.47). He also painted the contemporary landscape and went on sketching tours in North Wales and the Lake District.

It is said that Cristall's wife criticized his work on the grounds that it was insufficiently finished, but that, after trying to adjust himself to her views, he returned to his former broad manner. It is his broad manner which now forms the basis of the continuing appeal of his work. Cristall is the first to bring into watercolour that squareness and concentration on the basic facts of form which is an anticipation of Cézanne and Cubism. In my opinion, we may find in him the basis and origin of Cotman's first and greatest style. Cristall has a less attractive sense of colour and a certain

47 Joshua Cristall *Arcadian Landscape with Herdsmen by a River*

heaviness; but he had a fine sense of structure and used watercolour to express it in an original and legitimate way.

John Glover, who was also a founding member of the Old Water-Colour Society, was, in contrast, very successful both as an artist and as a teacher. He was the son of a small farmer and spent his youth in the fields of Leicestershire; but his ingrained fondness for art could not be gainsaid, and he graduated from the post of writing-master in a free school to become a teacher and artist on his own account. Glover developed ambitions as an oil painter, and in his compositions in that medium we can read clearly enough his desire to emulate Claude and Gaspard Poussin. He had paintings by Claude in his collection and was called – although scornfully when Constable used

the sobriquet – the 'English Claude'. In his water-colours the same influences are easily discerned, but the ambition is less strident and he is a sober and truthful unfolder of the picturesque and the romantic in English scenery. One of the identifying characteristics of his style is the use of 'split brush work' which he invented as a means of rendering foliage quickly and successfully. This consisted in separating the hairs of his brush into a number of fine points so that by one brush stroke he could represent a number of leaves, as it were, flickering in the breeze. He is also to be recognized by his extraordinary facility in rendering smooth water, a facility which he used to great effect in the sunset compositions which flowed naturally from his fondness for Claude. These tricks become mannerisms, and so prolific an artist could not fail to repeat himself and often be below his true standard; but at his best he brings a fresh and interesting element into the English watercolour school (Fig.48). Both Glover and Cristall were gifted in the drawing of mountainous scenery, especially that of the Lake District; but whereas Cristall reduces the hills to flat, angular forms, in Glover's drawings they are softly rounded with gentle, unangular contours.

48 **John Glover** *Landscape with Cattle*

52 **William Havell** *Garden Scene on the Braganza Shore, Harbour of Rio de Janeiro*

54 John Sell Cotman *Greta Bridge*

And he was able to develop. When he courageously went to Tasmania in 1831, at the age of sixty-four, the contact with a new landscape infused a more spectacular element into his style.

George Barret was, like Cristall and Glover, approaching his fortieth year when he too became a founding member of the Old Water-Colour Society. He is known as George Barret, junior, to avoid confusion with his father, who was a well-known landscape painter in his day and a foundation member of the Royal Academy. The son, working at the beginning of the nineteenth century, shows the full change in ideas and ideals which had come over the craft of watercolour drawing. Of a dreamy, poetic disposition, his art was latterly so closely modelled on that of Claude that it becomes almost an imitation: almost, but not quite, for the artist's quiet sincerity has made his own the classical composition irradiated by the glow of the setting sun, the softly tinted cool emptiness of the scene. He had a natural appreciation of these more romantic hours of the day and he wrote this typical passage in his book on *The Theory and Practice of Water-Colour Painting*:

> After the sun has for some time disappeared, twilight begins gradually to spread a veil of grey over the late glowing scene, which, after a long and sultry day in summer, soothes the mind and relieves the sight previously fatigued with the protracted glare of sunshine. At this time of the evening to repose in some sequestered spot, far removed from the turmoil of public life, and where stillness, with the uncertain appearance of all around, admits of full scope for the imagination to range with perfect freedom, is to the contemplative mind source of infinite pleasure.

Barret's works accord perfectly with the frame of mind he has expressed in these words. His view of Windsor (Fig.49) is of an ancient castle seen mistily through a grove. He re-creates the mood of Gray's 'Elegy in a Country Churchyard' and indeed his last work, now in the Victoria and Albert Museum, was entitled *Thoughts in a Churchyard – Moonlight* and was exhibited posthumously with these elegiac verses by the artist:

> 'Tis dusky eve, and all is hush'd around;
> The moon sinks slowly in the fading west;
> The last gleam lingers on the sacred ground,
> Where those once dear for ever take their rest.

Among the secondary artists who, like Cristall, Glover and Barret, exhibited at the first show of the Society in 1805 were Robert Hills, Francis Nicholson and William Havell. Hills specialized in the drawing of domestic animal life, sheep, cattle, and deer; and he is fairly in the line of distinguished English animal draughtsmen which begins in the seventeenth century with Barlow, goes through the eighteenth century to Stubbs, Morland and Ward, and found a later adherent in the nineteenth century in Landseer. His sketches from the life are carefully studied and full of knowledge and the etchings he made of cattle and 'groups for the embellishment of Landscape' were much used by both amateur and professional artists. His *A Village Snow Scene* (Fig.50) is a variation upon a theme of Rubens, and was so popular that he made at least three versions of the watercolour. Francis Nicholson, who also showed at the first exhibition of the 'Old' Society, was a technical innovator. In seeking a method of rendering highlights on paper he hit upon the expedient of coating the surface with a 'stopping-out' mixture based upon beeswax. The large series of views he made at Stourhead show this landscape garden, which had been designed to re-create the images of Claude and Poussin, in its maturity (Fig.51).

49 George Barret, junior
Windsor Castle

51 Francis Nicholson
Stourhead: The Bristol High Cross

65

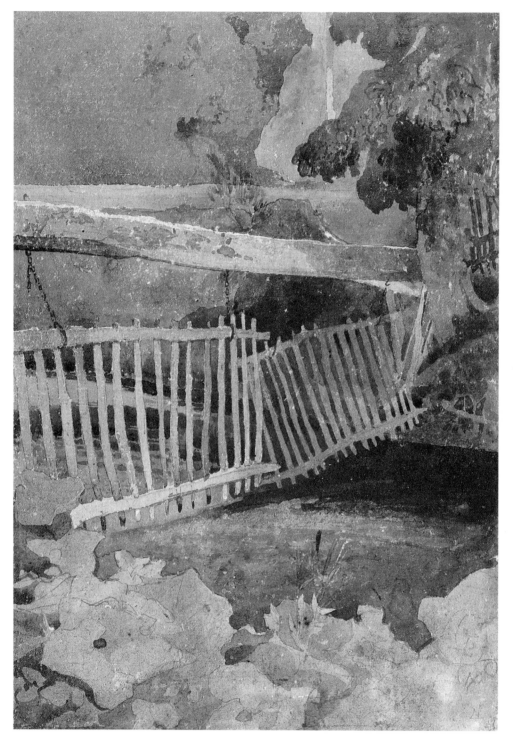

55 **John Sell Cotman** *The Drop Gate, Duncombe Park*

58 **John Sell Cotman** *The Lake*

William Havell was, at the age of twenty-three, the youngest of the exhibiting members in 1805. His work typifies the common approach of the members of the Society: the dependence of composition on the seventeenth-century landscape painters, the aspiration to vie with oil paintings, the rich tonality of the piece. Havell carried his competition with oil painting so far, particularly after a visit to more exotic scenery, that he incurred the displeasure of his fellow members through the free use of body colour. This was the criticism voiced about his *Garden Scene on the Braganza Shore* (Fig.52) when he exhibited it in 1827. He had made the sketch for it on the way to China in 1816.

Amongst the next generation of landscape painters George Fennel Robson was conspicuous for the zest with which he rose to the challenge of large compositions framed to rival oil paintings. His early sketching tours were spent in the Highlands, which the writings of Sir Walter Scott had elevated into a primary source of Romantic imagery. His *Loch Coruisk* (Fig.53) shows Robert the Bruce humbled by the sublime barrenness of the scenery, and was exhibited with a quotation from Scott's 'Lord of the Isles':

> Rarely human eye has known
> A scene so stern as that dread lake

To enter fully into the atmosphere of such scenes he had wandered over the mountains dressed as a shepherd, with Scott's poems in his pocket.

The success of the original Society of Painters in Water-Colours (the Old Water-Colour Society) led to the formation in 1807 of the rival Associated Artists in Water-Colours. This was relatively short-lived, but was replaced in 1832 by the New Society of Painters in Water-Colours which continues now as the Royal Institute of Painters in Water-Colours. These specialized groups played an important part in promoting patronage and in furthering the careers of their members. However, they became exclusive, self-perpetuating bodies, and many highly talented painters did not receive a just measure of recognition from them. For instance, John Sell Cotman is now regarded as one of the greatest watercolour painters of the English school, yet he was subjected during his lifetime to almost complete neglect. The reasons for his lack of success, insofar as they can be explained, lie largely in his own temperament. He had a manic-depressive disposition; wildly elated for a period, he would then be paralysed by the depths of depression. To this example of the supposedly modern artistic temperament was added another feature reminiscent of contemporary careers: that is, that his really creative and original work was done over a relatively brief period when he was young, and though thereafter from time to time he made new and exciting discoveries he was never again quite able to renew the first fine careless rapture of his youth. Though this may seem the index of a modern temperament, it is really the Romantic genius, comparable with the blazing youth of Byron, Keats and Shelley. If the artist of the eighteenth century felt such vagaries of emotion flowing in them they concealed the fact as best they could: the madness of J.R. Cozens and of Clare, the poet, may have been occasioned by such a make-up; but in the early nineteenth century there were fewer reins on sensibility, and the letters of John Sell Cotman alone give a clear index to his lovable, extravagant and wildly unstable character.

J.S. Cotman was born in Norwich in 1782; and, having decided that he must devote himself to art, came to London at the age of sixteen or seventeen in 1798. Here he was befriended by Dr Monro, and became another instance of that

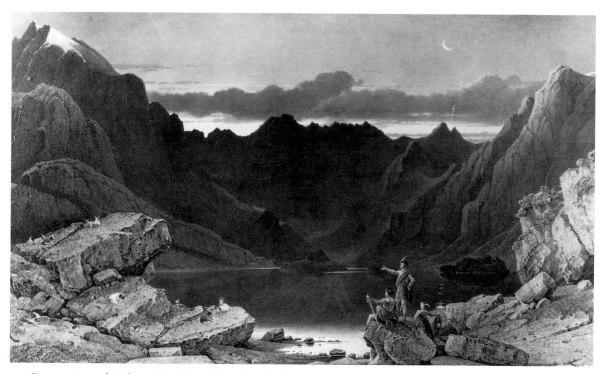

53 **George Fennel Robson** *Loch Coruisk and Cuchullin Mountains, Isle of Skye*

connoisseur's remarkable flair in choosing promising young men. As were Turner and Girtin five years before, he was set to copy outlines and trace drawings. So far as the early formative influences on his style can be identified, the strongest is that of Girtin, filtered perhaps through that of Edridge. But before his visits to Dr Monro, Cotman had undertaken the hack-work of hand-colouring aquatints at Ackermann's Depository. It would be easy to overestimate the effect of this sort of drudgery on a young artist's development – Turner and other watercolourists had coloured prints by hand in their time. But in the greatest of his original work which he produced four or five years later, Cotman shows such a love of the flat, unmodulated wash, such a precise

control over its edges, and such a delight in the juxtaposition of bright colours, that one is tempted to trace the origins of that style to this very occupation. And just such a predilection may have been strengthened by the sight of Cristall's watercolours with their emphasis on structure and angularity.

Cotman lived the typical life of the young artist struggling for recognition in the London of his day. He hawked drawings round the print-sellers' shops, lived with like-minded companions, went with them on sketching tours in the country in the summer, and was a member of a sketching club. These sketching clubs have some importance both as a symptom and a cause of the increasingly poetical trend of watercolour painting from the

69

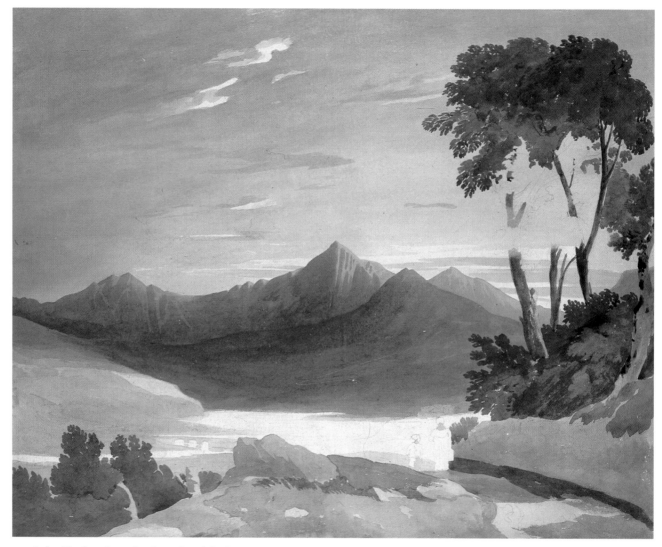

59 John Varley *Snowdon from Capel Curig*

60 John Varley *Hackney Church*

year 1800. Girtin had been a founder member of the club of which Cotman became a member in 1801, and it followed the very simple regimen of meeting by turns in each member's rooms, to draw from imagination an illustration to a striking passage chosen from the poets. The poets chosen for illustration included Ossian, Thomson and Gray. Such a club provided the perfect counterpart to the visits to Dr Monro: at Monro's the mechanical copying and tinting of outlines gave training to the hand and executive talents, whereas in the sketching clubs niceties of execution were set aside and the imaginative faculties of the members were given full play. Cotman's contributions included striking fantasies on such Ossianic subjects as 'They came to the Halls of the Kings'.

Cotman went on a summer sketching tour to Wales in 1800, and on three successive years to Yorkshire, in 1803, 1804 and 1805. These visits to Yorkshire were the great liberating experience of his life; in the course of them his style developed naturally into its full originality, and his treatment of what he saw was lyrically fresh. On each occasion he stayed with the Cholmeleys of Brandsby, a family which had befriended him, and on the last visit he went farther north also to stay with the Morritts at Rokeby Park, on the River Greta. The finest of all Cotman's watercolours are connected with this stay of his at the River Greta: for instance, his *Greta Bridge*, now in the British Museum (Fig. 54), and his *Drop Gate, Duncombe Park* (Fig. 55). These are drawings in which everything inessential is ruthlessly suppressed and yet every nuance of the scene is there. In them, Cotman adjoins to his perfectly controlled washes a deep and vivid sense of colour harmony.

And yet, probably because of their originality, these drawings did not sell; it was at this stage,

56 **John Crome** *Landscape with Cottages*

and at the early age of twenty-four, that Cotman's career began to go wrong. Instead of staying in London he returned to Norfolk, where the local school was making its name, and had recently held its first public exhibition. Its most eminent member, John Crome, mainly worked in oils, but made a few low-toned watercolours in which he applied his affection for the Dutch artists to the East Anglian scene (Fig. 56). Cotman also planned, it seems, to tackle the problems of painting in oil. But the prestige of the Norwich school was one thing, its economic basis quite another. Thenceforward Cotman's means of subsistence were an anxiety to him and became easier only by the acceptance of appointments as drawing master. Yet in the intervals of hack-work, which was

particularly perilous for one of his unstable temperament, he found it in him at times to reproduce the cool, smooth crispness of his Yorkshire period.

When he moved to Yarmouth under the patronage of Dawson Turner the sight of the sea with its animated succession of shipping led him to create *The Dismasted Brig* (Fig.57) in which the emotion caused by the foreboding of disaster is enhanced by the consummate control of the sharpedged, flat washes of watercolour. With the encouragement of his patron he became an enthusiastic antiquarian; he turned out scores of drawings of Norfolk churches, and he paid three visits to Normandy in quest of early architecture. But at other times, when he was convinced that the

public did not like his style, he tried to paint in a more acceptable manner; then his watercolours fell into the contemporary heresy of vying with oils, and they became hot and arid in colour, flamboyant and artificial in feeling.

At length, at the age of fifty-two, he accepted a post as drawing master at King's College, London. He entered on it in a fit of enthusiasm as a chance of escaping from his financial distress and of reappearing in the centre of the British cultural world. But the change did not do as much as that for him; his duties involved the manufacture of hundreds of drawing copies with the aid of his family, and he was subject to the same acute ups and downs of feeling. Even then,

57 **John Sell Cotman** *The Dismasted Brig*

61 David Cox *The Pont des Arts and the Louvre from the Quai Conti, Paris*

63 David Cox *Haddon Hall: The River Steps*

during the last years of his life he produced a mystical and tempestuous series of drawings of Norfolk scenery, and some watercolours of which both the style and medium were a new development (Fig.58). These drawings were made with a paste medium believed to be derived from rotting flour; and with something of the luminosity of oil Cotman produced serene and penetrating works, apparently for his own eye alone, which are completely satisfying.

Cotman might well have been expected to become a member of the Old Water-Colour Society but was not elected when he applied in 1806. After his retreat to Norfolk he seems to have intended to devote himself to oil painting. At any rate, whatever the reason, he lost touch with this and all other representative London artistic institutions. He did not become an associate member till 1825, when he exhibited with the Society for the first time, and never obtained full membership.

The next important watercolourist of the early nineteenth century to attract attention is John Varley. He was a foundation member of the Old Water-Colour Society and one of its most prolific exhibitors, being represented by no fewer than forty-two drawings in the first of its exhibitions. In the thirty-nine years in which he was connected with the Society he sent as many as 700 works to its exhibitions. His disposition was completely opposite to that of Cotman, being uniformly sanguine, and he enjoyed a great vogue both as a painter and a teacher; yet his outward prosperity was scarcely greater than Cotman's, for he was a reckless spendthrift and was constantly in and out of the debtors' prison.

John Varley attracted the notice of Dr Monro at the age of twenty and, like the other young men of talent who were recognized by that connoisseur, was set to copying, a year or two before Cotman's entry on the same scene. The strongest influence upon his early style, naturally enough, as it was the strongest influence in England at the close of the eighteenth century, was that of Girtin. A visit to Wales developed in him a predilection for mountainous scenery of which the recollection remained with him to his latest work (Fig.59). But he was not without higher ambitions, and sought to extend the range of his subject matter by compositions on such subjects as *Scene from the Bride of Abydos*, in the Victoria and Albert Museum, an illustration to Byron showing a thousand tombs and cypresses against an evening sky. He was also fertile in his search for new techniques, and just as Cotman had developed his rotting flour paste mixture to bring some of the depth and richness of oil into watercolour, Varley sought to achieve the same result by the lavish use of gum and even by varnishing his drawings.

There was curiously blended in Varley a mixture of the scientific and the visionary faculties, and he did not really succeed in bringing both sides of his nature to full fruition in his drawings. There can be little doubt that he was what we now call 'psychic'. There are many convincing accounts of his flair for premonitions, and an impressive list of prophecies by him which were subsequently and unaccountably verified. Yet this taproot which he had into the occult did not serve, as it served Blake, to nourish the imaginative content of his art. He is a craftsman of great accomplishment, but in essence a manufacturer of picturesque scenes to a formula. It is a respectable, even an attractive formula, derived from the study of Gaspard Poussin and Claude; but once the key of the formula has been comprehended it becomes a little wearisome. In some of the early work there are signs of greater possibilities, of an imaginative creation out of nature, but the

preponderance of stereotyped drawings by Varley is easily understood. He was extremely facile, and when drawings were needed overnight to furbish up an exhibition he would produce what were known as 'Varley's hot rolls'. An assiduous practice as a drawing master and the harassing nature of his debts prevented him from concentrating his vision or having frequent recourse to its springs; and there is again his own remark, 'Nature wants cooking', to explain these shortcomings. Yet it is when he conceals the culinary process that he is at his most convincing, as in his *Hackney Church* (Fig.60). The apparent spontaneity of this scene which Varley had known from childhood – he was born in a house overlooking the churchyard – is explained by the artist's note on the back 'Hackney Church, a Study from Nature, J. Varley, July 21st, 1830'.

Unrestricted praise, however, may be accorded to Varley's activities as a teacher. In imparting the principles of watercolour painting he undoubtedly had the root of the matter in him, and it is as a teacher, in the work of his pupils and those who came indirectly under his influence, that he made his abiding contribution to this branch of English art. When it is remembered that men of such diverse gifts and temperaments as David Cox and Samuel Palmer, F.O. Finch and Copley Fielding were his pupils it will be apparent that he did not impose his own vision on his scholars but, as education truly signifies, drew out of them what was latent in them. One reason for this excellence is to be found in his published *Treatise on the Principles of Landscape Design* which is an admirably sustained logical analysis of its subject, and emphasizes the need for breadth in a drawing at the expense of too great attention to detail. 'Every picture should have a "look there!"' he is reported to have said. He considers that contrasts of all kinds, in shape, colour, texture and movement,

are the true exercise of art. In another pregnant saying he records that oil painting may be compared to philosophy while watercolour drawing resembles wit, which loses more by deliberation than is gained in truth.

Hitherto, with the notable exception of Cotman, the members of the Old Water-Colour Society whose work has been considered were artists already established or whose talents had become apparent by its foundation in 1805. Any such society has very soon to exercise itself about the recruitment of new talent. In this first decade of is existence the Old Water-Colour Society chose wisely, and picked from a very large field of professional artists many of whom we may say, being wise after the event, that they were the best watercolourists of the second quarter of the nineteenth century. Of the new blood thus judiciously introduced, the three outstanding men were Peter De Wint, who became an associate in 1810 and a full member in 1812; A.V. Copley Fielding, who also became an associate in 1810 and a full member in 1812; and David Cox, who became an associate in 1812 and a full member in the same year. David Cox was, however, a year older than De Wint and five years older than Fielding, and therefore deserves precedence of treatment.

Cox did not frequent the house and collection of Dr Monro, but he graduated to painting through what was perhaps an even more prolific channel of supply for artists at this period – that is, scene-painting for the theatre. As it had been for David Roberts, Clarkson Stanfield and many others, theatrical scene-painting was the means whereby Cox emancipated himself from his restrictions; in his case, of poor chances in his native Birmingham which he left for London and eventual recognition as one of the most characteristic of the English watercolourists. He came to London about 1805,

65 **Peter De Wint** *Gloucester from the Meadows, 1840*

68 John Constable *Cottages on High Ground*

fell under the influence of Girtin and had lessons from John Varley. Nor is it surprising that while he was learning to feel his feet he should have copied in watercolours a typical painting by Gaspard Poussin which was in a dealer's shop at the time. This painting of a ruin in a dark setting of trees, with a shepherd and his flock in the foreground, and pervaded by the evening light, exercised a great influence over the watercolours Cox painted in the next fifteen years and more.

Cox maintained that Wales could provide all the scenery necessary for the Romantic vision. Yet his few excursions abroad enriched his production with one of his most carefully contrived and colourful compositions, the *Pont des Arts and the Louvre from the Quai Conti* (Fig.61), worked up from a sketch he made during his only visit to Paris in 1829.

The Cox whose work is most familiar in private collections and art galleries is the later Cox, the Cox of windswept heaths, stormy seas, and effects of atmosphere and light; but for the first two decades of his maturity he worked in another more traditional and more solid way. During that period he produced a number of technical treatises embodying his teaching on the theory and practice of watercolour painting, and these reveal him as an exponent of the eighteenth-century idea of the picturesque, modified by the technique of such of his contemporaries as Varley. There is something monumental and satisfying about Cox's treatment of the picturesque. He translates the logical construction found in Poussin and makes it fit much more closely to the English landscape than Varley, in whom the machinery is often too apparent. There is also less potboiling and uninspired repetition of themes in this earlier manner. But, despite the vagaries and lapses of the later style, the critical judgment is right which sees in it Cox's greater achievement and more

original contribution to our art. It is difficult to resist the temptation of calling it an anticipation of Impressionism, because of the sensitiveness to light and transient effects of atmosphere displayed in this later style. There may indeed be the relation of cousinship between the style of Cox and that of the early Impressionists. The nearest French equivalent to Cox is to be found in Eugène Isabey, and both Cox, after his visit to France in 1829, and Isabey learned much from the airy, feather-light brilliance of Bonington. Isabey was of importance to the development of Boudin, who in his turn was a decisive influence upon Monet.

But whether these considerations are well founded or not, Cox does, in the best of his later work, introduce the elements – wind and wave, air and water and light – as dramatic motives. They sweep across the unchanging landscape, they almost engulf the traveller on his way. Such conceptions are a welcome contrast to the monumental calm of the founders of the English watercolour school and of Cox's own earlier style (Figs62, 63).

De Wint dominates the watercolour painting of the second quarter of the nineteenth century with Cox and Copley Fielding. He had been apprenticed, while still in his teens, almost at the beginning of the nineteenth century, to learn engraving and portrait painting, but his native bent for landscape painting asserted itself so strongly that he was released from his indentures and enabled to follow his desire. He was also at about the same time introduced to Dr Monro, and in his collection of English watercolour drawings admired those by Girtin most. He enjoyed steady, if modest, patronage as draughtsman and as teacher almost from the outset, but his period of wider fame is to be dated from the time when he rejoined the Old Water-Colour Society in 1825. He had more right than most of his

62 David Cox *The Night Train*

contemporaries to attempt to emulate in his watercolours the richness and depth of colour of oil painting, for he was himself by preference a painter in oils. The surviving examples of his work in this medium show how adequate his technique was to express the whole range of his ideas. In their turn the oil paintings serve to explain his fondness for a deep, harmonious colouring, pervaded by a love of the strawberry roan colour of the cows which are so inevitable a feature of his landscapes.

De Wint is the most decided of the followers of Girtin, and especially he found in him encouragement for the painting of the flat and at first sight featureless Midland counties in which he felt most at home. So wedded was he to the long level expanse that the very shape of his drawings reflects this liking of his: they are often abnormally long in proportion to their height and sometimes give the impression of a strip to which additions can be made indefinitely. Rather than seek the orthodox sources of the picturesque,

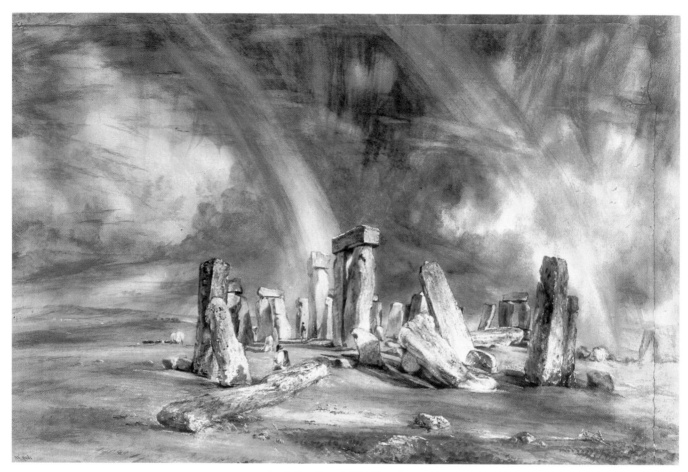

69 John Constable *Stonehenge*

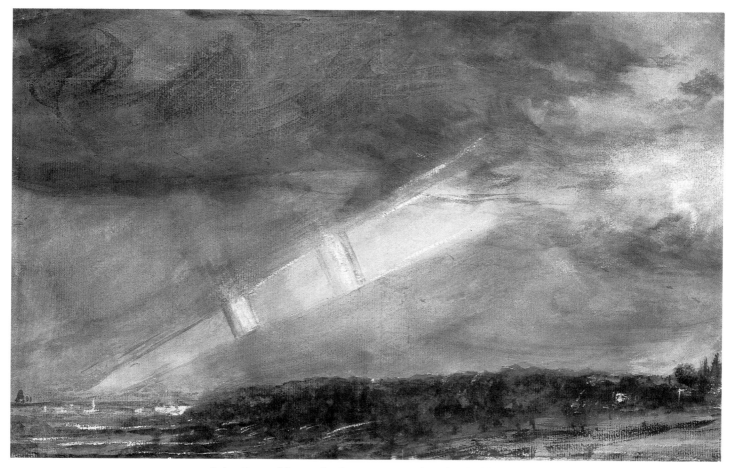

70 **John Constable** *London from Hampstead, with a double Rainbow*

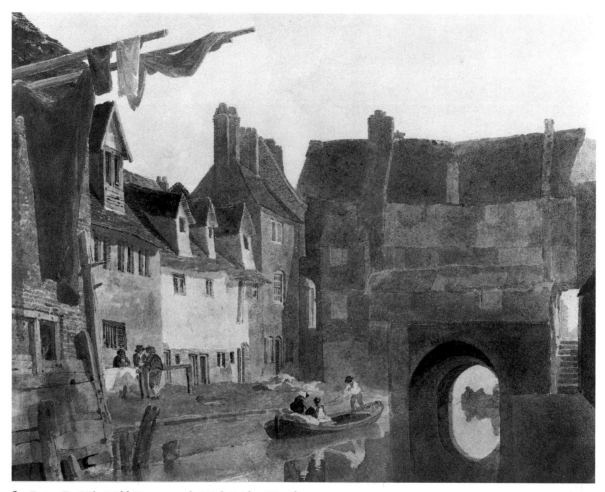

64 Peter De Wint *Old Houses on the High Bridge, Lincoln*

De Wint would spend summers in the neighbourhood of Lincoln drawing not only the cathedral in its magnificent position but also the surrounding fields, marshes, swamps and the alleyways of the city (Fig.64). If Girtin had not performed similar wonders before him there would be all the more reason to be amazed at the interest and variety, the sense of warmth and humanity, which De Wint conjures from this unpromising scenery.

He united in a high degree the powers of generalizing with the power of concentrated design. He does not in his best works carry the drawing of his foliage or his architecture to a high degree of definition: it is all adequately stated in the language of the sketch, and yet each part is governed by a profound and concentrated sense of structure and of its place in the unity of the whole scheme. It is our confidence

in the artist's power of synthesis which gives so satisfying a sense of completeness and repose to our contemplation of his work. He does not greatly vary his subject-matter in search of wildly romantic scenery, or to play upon a range of atmospheric effects. His theme is generally the immemorial one of the English countryside, watched over by the cathedral (Fig.65) or the scene of haymaking in the summer days; or possibly it may be the low level reaches of a river with antiquities mirrored in its calm, grey surface. It is set down naturally and in accordance with De Wint's innate sense of design, and always with his singularly rich power of colouring. When, unusually for a watercolour painter at this time, he set out to paint a still life, his delight in the precocity of his technique, and his control of contour and wash, is quite apparent (Fig.66).

As befits his approach to art, which was neither derivative nor the fountainhead of a new departure in the school, De Wint's attitude to his fellow artists, as with dealers, was standoffish and remote. But one of his contemporary landscape painters bought from him, and that one was John Constable. There could be no greater

66 Peter De Wint *Still Life*

tribute to De Wint's artistic integrity.

To his contemporaries of the second quarter of the nineteenth century the fame of Copley Fielding stood equal with that of Cox and De Wint, but his reputation does not bear the same scrutiny today. He prospered exceedingly and made a large fortune by his art, in times when De Wint was content with moderate prices, Cox was not prosperous, and Cotman chronically the reverse of prosperous. Here is some concrete evidence for the oft-repeated assertion that the taste of the new class of art patrons was on the decline in this epoch. But we must not judge them too harshly, for Ruskin too, while admitting that Copley Fielding had faults, was moved to accord him a very high place in art. When preparing his readers for his declaration of the full superiority of Turner in the first edition of *Modern Painters*, Ruskin enrolled Copley Fielding amongst those who were more beautiful, more true, more intellectual than Poussin and Claude, typifying him as 'casting his whole soul into space'. A more balanced nineteenth-century judgment on him reads: 'He fell into the most rigid mannerism of self-repetition, crudeness of colour, and feeble or blurred confusion of detail, and yet from isolated specimens of his work it might seem as though he might have been second only to Turner among water-colour artists.'

Copley Fielding came to London in 1809 and it is said that when he presented himself to John Varley he showed so little aptitude for improvement that Varley did his best to dissuade him from following the career of an artist. He frequented Dr Monro's, and his drawings of this early period show an almost slavish devotion to Varley's principles. Once he had sketched out for himself the formula he repeated so often, of moorland and distant hill, with a brown, undifferentiated foreground traversed by a rutted path,

71 **R.P. Bonington** *Medora*

73 **R.P. Bonington** *A Venetian Scene*

67 A.V. Copley Fielding *A Ship in Distress*

he never failed of success. His only other develop-
ment took place when, on an enforced sojourn at
Brighton for his wife's health, he fell under the
spell of the sea (Fig.67). Thereafter sea pictures
bulked equally with distant mountains and moor-
land mists in his work. He was, if possible, even
more prolific and facile in execution than John
Varley and, in the course of fifty-four years,
exhibited the surprising total of 1,671 drawings
with the Old Water-Colour Society. He was
President of the Society, and thus the official
representative of English watercolour, for the last
twenty-five years of his life.

It is a relief to turn from Copley Fielding to an
artist whose originality and single-minded de-
votion to the highest potentialities of his art are
beyond doubt. John Constable does not come to
mind in the first instance as a member of the
school of watercolourists: for one thing, he him-
self during the greater part of his maturity thought
and worked so thoroughly in terms of oil painting
that his use of watercolour was spasmodic and
secondary. But to be the painter of the complete
truth of nature, as he set out to be, Constable
had constantly to be out in the fields making
notes of the scene before him, often in pencil,
often in oil, but sometimes, and more frequently
toward the end of his life, in watercolours.

Constable succeeded in freeing himself entirely from the habits of vision and picture-making with which we have become familiar in this survey – in particular from the 'picturesque' tradition of composition. He saw and drew things as they were, without tricks of style, and so when he came to use watercolours in the period of his full mastery, he did so with originality and a new expressiveness. But these works of his maturity were preceded by a remarkable group which he produced in 1806, when he was thirty years old. Constable was unusually late in developing, and started with far less manual dexterity than most of the precocious youths who became famous artists. In 1806 he paid his solitary visit to the Lake District. Leslie records in his *Life* of Constable that the artist did not feel at home in the mountains of which the solitude and vastness depressed him. He exhibited a few finished oil paintings and then dropped the theme of the Lakes abruptly from his repertoire. At the time he had made a remarkable series of watercolours, the majority of which stayed in his keeping. These drawings betray unmistakably the strong influence of Girtin, but they are the fruit of incessant and excited sketching, and in their unpretentious way they express as no other series of drawings or paintings has done the very qualities by which Constable was oppressed – the solitude and the grandeur of the hills. Both from the drawings themselves and documentary evidence we know they were made by the artist on the spot, mostly sitting in Borrowdale in the presence of the majestic massifs. To his contemporaries at this time Constable's style was sufficiently exceptional to give them the impression that he was aiming for effect; but on the back of some of these Lake District sketches we find notes by the artist comparing what he has seen and attempted to draw with specific paintings by Gaspard Poussin, thus emphasizing once again the dependence even of our most original minds on the main tradition of seventeenth-century landscape.

When after this brief early experiment he took to watercolour again in the later phase of his career, Constable was fully aware of what he was seeking in nature. To be a natural painter he had to drop all tricks of composition, all purely formal rules of picture-making. At the same time he had to express the evanescent no less than the permanent: the ever-changing shapes and colours of the clouds he had watched avidly since his childhood as the son of a miller, the white of leaves beaten up by the wind, the dew on grass and sunlight on tree stumps. All these functions of changing light and colour were to be part of his expression of the outer world. Watercolour became a handmaid to his pencil and his oil colours in catching these transient appearances at the moment they were seen. The unpremeditated method of their use and the self-trained and scrupulous honesty of Constable's vision ensured the freshness of these sketches, whether cloud studies or notes of buildings, trees or country (Fig.68).

In the last years of his life he took to exhibiting watercolours as finished expressions of his art. This course was partly forced upon him by illness; in 1834 he was only able to send four drawings to the Royal Academy's annual exhibition. One of them was a large watercolour of Old Sarum, in which he developed his technique to express his sense of the evanescent qualities of light. He carried this method even further when he exhibited his watercolour *Stonehenge* in 1836 (Fig.69). This is an intensely Romantic rendering of the emotions evoked by ancient, inexplicable ruins, and its poetry is enhanced by the double rainbow which he cherished as a brilliant phenomenon of light and as a symbol of hope (Fig.70).

74 **Thomas Shotter Boys** *The Boulevard des Italiens, Paris*

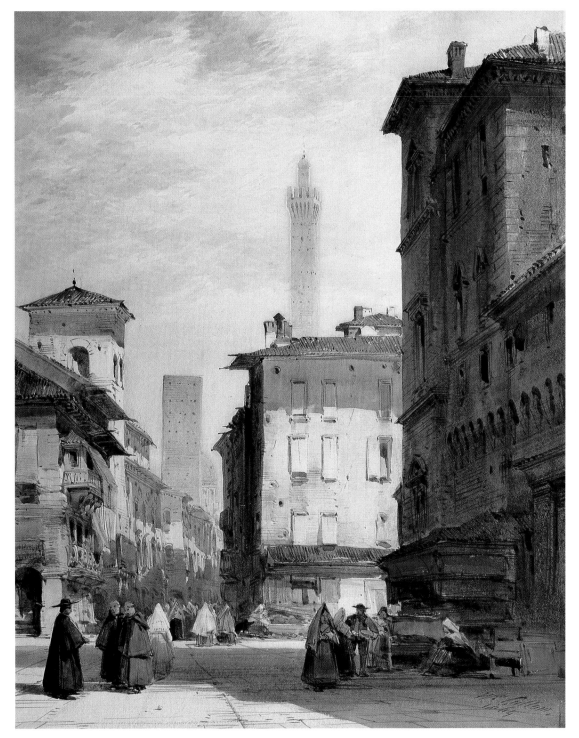

76 William Callow *The Leaning Tower, Bologna*

It is from another painter who made a great contribution to oil painting that a strong revivifying breath comes to the English watercolour school in the 'twenties of the nineteenth century. Although he only lived to be twenty-five, Bonington crystallized the prevailing tendencies of his time so well that he not only left a body of great work behind him but he had a strong influence on his contemporaries and successors both in France and England. Both English and French elements entered into his training: his father, a landscape and portrait painter of Nottingham who no doubt gave him some training, took him to France at the age of sixteen or seventeen, and it was in France that most of his working life was passed. There the young artist took lessons in watercolour from Louis Francia, who had imbibed the English watercolour tradition in association with Girtin, and was newly set up as a teacher in Calais. Subsequently Bonington went to Paris and worked at one of the foremost studios there; he was much admired for his facility and brilliance of execution, and Delacroix was his friend. He came to share the enthusiasm felt by Delacroix for Byron's Eastern romances and their star-crossed lovers (Fig.71).

Bonington paid a visit to Venice and made one or two journeys to England. Such was the effect of his watercolours in France at the time of their execution that the young Corot was spellbound and deeply influenced by catching sight of one in a dealer's window while on an errand. Their predominant characteristic is lightness of touch combined with certitude and accuracy of drawing. He models with the broad, swift strokes of the sketch, but every touch is in place and he does not destroy the first effect of spontaneity by elaboration. The wash has as it were a soufflé-like lightness on the paper. Whereas Peter De Wint seems to be drawing in heavy elements, in earth itself, Bonington draws in air and colour.

In landscape, Bonington's favourite subjects were seascapes from the levels of the French coast. He made many topographical street scenes of Paris and other picturesque towns with a delicacy in the treatment of architecture which contrasts strongly with the heaviness of some other topographical draughtsmen, such as Prout. Latterly, when he also came to take up painting in oil, he painted a number of historical pictures in the style of the French romantic school, with members of which he was associating. A visit he paid to Venice in 1826 provided him with fresh opportunities both for picturesque architectural topography and for romantic historical painting (Figs 72, 73).

The followers of Bonington felt his influence in both these categories. The lightening of texture in the later works of David Cox seems to be directly traceable to his new acquaintanceship with Bonington's style. In France his admirers included such artists as Eugène Isabey, who through Boudin exerted an influence on the Impressionists. A whole group of rising artists gave proof of their respect for his methods, the most notable among them being Thomas Shotter Boys, John Scarlett Davis, James Holland and William Callow.

Boys, in particular, made drawings of the Parisian street scene which rival those of Girtin and Bonington. In them the vertical moulding of the repetitive ornament in the architecture are rendered by the fine brisk parallel strokes common to this group, and the skies are drawn with the understanding natural to so many members of the English school of watercolourists (Fig.74). Boys is known to a large public through his lithographic views of Paris, and also by his lithographs of London in 1842, in which with a similar fidelity and appreciation for space he has recorded

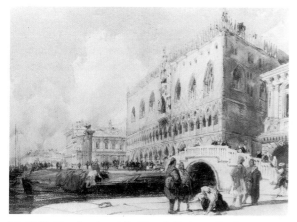

72 R.P. Bonington *The Doge's Palace, Venice*

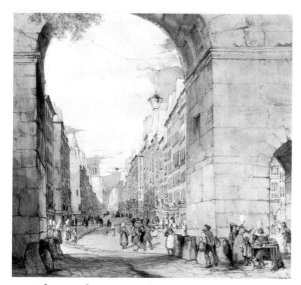

75 **John Scarlett Davis** *The Porte St Martin, Paris*

and twenty-ninth years. Like Bonington and Boys, he paid much attention to drawing the Parisian street scene. There was indeed almost a craze at this time among amateurs of drawings for such delineations, stimulated no doubt by the sealing off of the Continent during the period of the Napoleonic Wars. Callow became, like other artists of the second quarter of the nineteenth century, a vigorous traveller abroad in search of picturesque architecture (Fig.76). His career was a remarkable one, for he continued to paint skilfully in the Bonington tradition till the closing years of the nineteenth century and in fact lived until 1908, when he died at the age of ninety-five. He was one of the artists who helped to maintain the standard of the exhibitions of the Old Water-Colour Society in the second half of the nineteenth century, and was secretary of that body between 1865 and 1870.

James Holland was born in the Potteries, and like Renoir began his painting career in the decoration of ceramics. He too became a far-travelled man in Europe, notably in Portugal, which he visited under a commission from a publisher to supply drawings for an engraved annual, and in Venice. It is of Venetian scenes that his most colourful and forceful later drawings were made (Fig.77). In them he made much use of body colour; in brilliance of colour and virtuosity of handling, these drawings represent the method of Bonington pushed to its farthest possible extremes. That Holland knew the value of sketches is established by his remark that 'parting with a sketch was like parting with a tooth, once sold it cannot be replaced'.

Samuel Prout earned a widespread reputation through his renderings of ancient and picturesque Continental architecture (Fig.78). His most typical works are certainly drawn with uniform, though mannered, ability, colourful and enlivened by gay

the image of early-Victorian London. In his earlier work, John Scarlett Davis draws the streets of Paris in a manner which, though it derives from the same example, is more linear and less fluid in handling (Fig.75).

William Callow worked for a time with Boys at Paris and lived abroad between his seventeenth

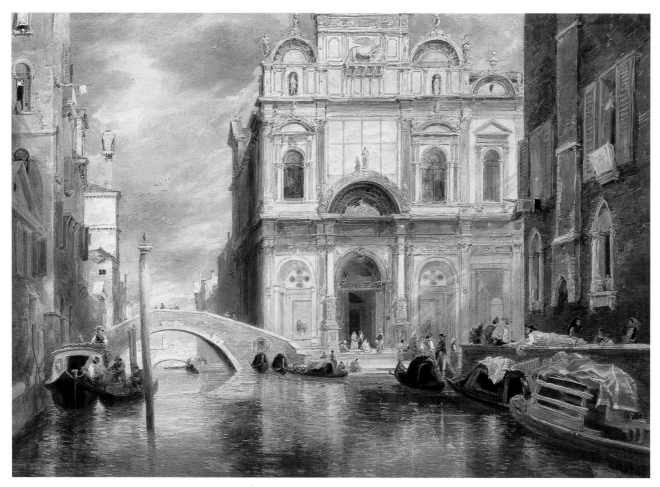

77 James Holland *Ospedale Civile, Venice*

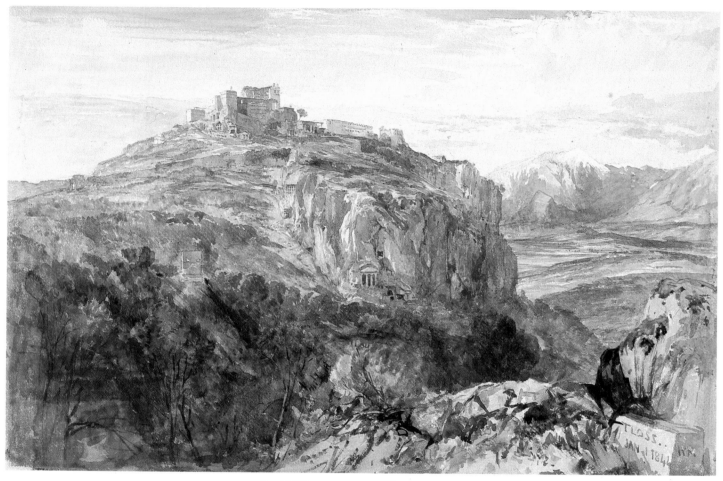

80 William James Müller *Tlos, Lycia*

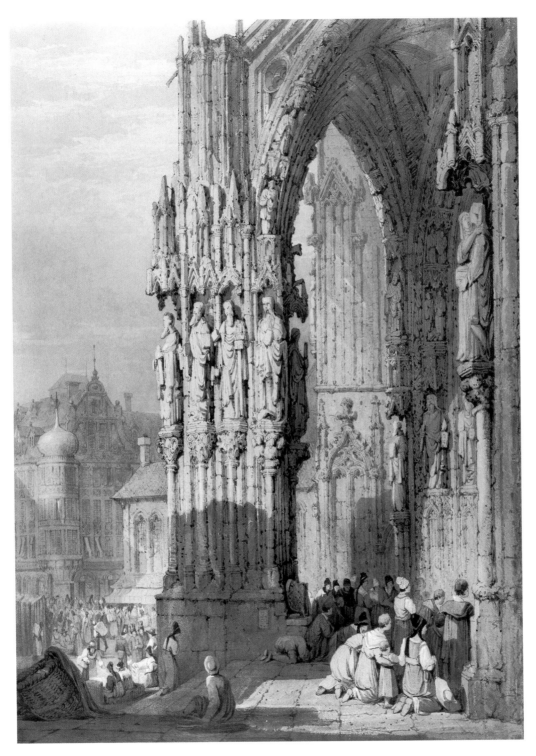

78 Samuel Prout
Regensburg Cathedral

83 **William Turner of Oxford** *Donati's Comet 1858*

window-blinds and groups of rather triangular figures. An earlier and unfamiliar phase of Prout's style, in which he draws in cold greys and low tones, is far more pleasing. The subjects of these works are generally picturesque cottages and hamlets of Cornwall or Devon. But his success was built upon his diligent travels, from which he derived scenes which roused curiosity and conjured up tantalizing desires to follow in his steps. John Ruskin records how his father brought home a copy of Prout's lithographic *Sketches in Flanders and Germany*: 'As my mother watched my father's pleasure in looking at the wonderful places, she said why should we not go and see some of them in reality? My father hesitated a little, then with glittering eyes said – why not?' Ruskin repaid his debt to the originator of his foreign travels by enrolling Prout amongst the living artists who had shown their 'superiority in the art of landscape to all the ancient masters'.

The growing taste for travel played its part in enticing artists to make even longer and more

adventurous journeys. David Roberts was one of the first to seek novelty and richness of architecture in Spain; then he went even more boldly to Egypt and the Holy Land in 1838 and 1839 (Fig.79).

William James Müller was another early visitor to Egypt and Greece, and in 1843 he became the official draughtsman to the Expeditionary Force in Lycia. The exceptional breadth of his watercolour technique is demonstrated most particularly in the sketches he made on that expedition (Fig.80).

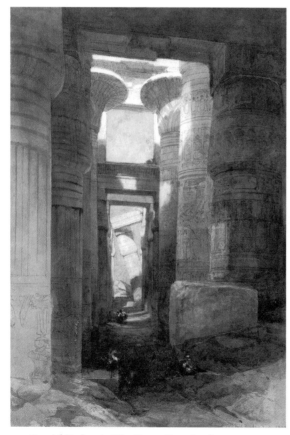

79 David Roberts *The Great Temple of Ammon, Karnac, the Hypostyle Hall*

Clarkson Stanfield had, like David Roberts and David Cox, begun his career as a scene-painter; he transferred the sense of drama which this calling entails into his topographical watercolours, and even more into the sea paintings for which he gained a notable contemporary reputation. To Ruskin he was 'stern and decisive in his truth'. The dangers of the sea needed no emphasizing to this maritime nation; the horrifying number of shipwrecks was a constant reminder of its perils. But the melodramatic note in *A Storm* (Fig.81) is also to be understood in the context in which it was to be exhibited. George Scharf's interior of the New Watercolour Society (Fig.82) shows the crowded screens and the heavy frames enclosing large watercolours customary in the exhibitions of these earlier years of the nineteenth century. To make a mark in such surroundings any composition had to be bold and dramatic.

William Turner of Oxford's *Donati's Comet* held the attention of the visitors by its exceptional and moving subject, in spite of its relatively small size amongst exhibition pieces (Fig.83).

An interest in the historic past was as much a feature of the Romantic movement as the delight in exotic travel. As we have seen, Bonington was an early exponent of scenes set in the supposedly correct costume of an earlier century or an exotic land. Amongst the many watercolour painters who supplied collectors with such reconstructions George Cattermole was one of the most conscientious and prolific. He is probably best remembered now for his illustrations to Dickens's *The Old Curiosity Shop*, which were engraved on wood and are still reprinted; his feeling for old buildings and for antique furniture were well employed in these designs, and culminate in the scenes of Little Nell's death and her grandfather's constant watch by her grave.

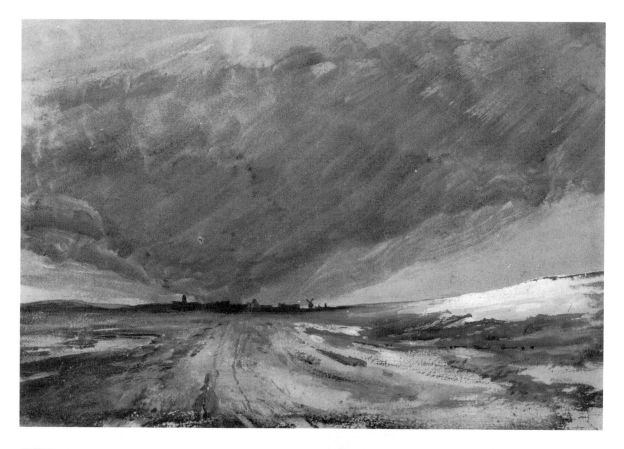

81 Clarkson Stanfield *A Storm*

82 George Scharf *The Gallery of the New Society of Painters in Water-Colours, 1834*

99

88 William Blake *The River of Life*

90 **Edward Calvert** *A Primitive City*

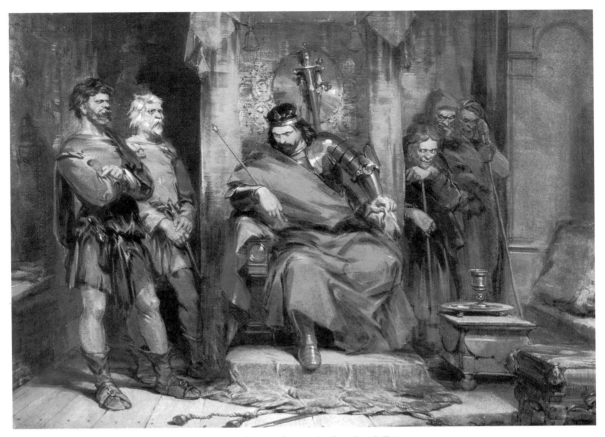

84 George Cattermole *Macbeth instructing the murderers employed to kill Banquo*

His antiquarianism reflects an essential ingredient of the Gothic revival, and gives a sense of authenticity to his theatrical scenes such as his illustration of Macbeth instructing the murderers employed to kill Banquo (Fig.84).

One of the most lively contemporary developments in figurative watercolour painting came through the increasing demand for portrait drawings, as a halfway house between the portrait miniature and the oil portrait. One of the most active in this genre was Henry Edridge, a versatile man who was a successful miniaturist and landscape painter. As a portrait draughtsman he is the nearest English equivalent to Ingres. His drawing

of Thomas Hearne in Ashstead churchyard was made in 1800, when the two artists were staying with their friend Dr Monro at his country cottage near Leatherhead (Fig.85).

The nineteenth century rebelled against the savagery of eighteenth-century caricature, watering its fury down into the genial comedy of such drawings as A.E. Chalon's *The Opera Box* (Fig.86). Whilst the street scenes which had so fascinated the founders of the English watercolour were not neglected, the subject matter was now often taken from the higher reaches of society, as with the visiting French artist Eugène Lami recording a scene in Belgrave Square (Fig.87).

87 Eugène Lami *Scene in Belgrave Square* ▷

85 Henry Edridge *Thomas Hearne in Ashstead Churchyard, Surrey*

86 Alfred Edward Chalon *The Opera Box*

92 Samuel Palmer *In a Shoreham Garden*

96 John Linnell *Mrs Wilberforce and her child* ▷

ater Colour M.ᵉ William Wilberforce by John Linnell 1824

The artist who most truly brought the eighteenth-century tradition of figurative composition into the early years of the nineteenth century was William Blake. Yet his extensive and powerful influence was spread more by his small number of idyllic Arcadian woodcut landscapes than by the illustrations to his Prophetic Books. If we except one of two friends and patrons, contemporary appreciation passed Blake by. Veneration for him was kept alive by a small cult but it did not become more general till, in the 'fifties, Rossetti, the biographer Gilchrist, Swinburne and others connected with the Pre-Raphaelite movement, began to be aware of his extraordinary merits. The growth of a still more popular appreciation of Blake, which has at length led to his acceptance as one of the great masters of English art, no less than of English literature, dates only from exhibitions of the twentieth century. To take Blake seriously before 1850 was to invite the supposition that one was slightly mad, and in the second half of the nineteenth century it would still have been paradoxical.

Blake's vision did indeed penetrate through to the fundamentals, but he expressed the difficult truths of which he had caught a glimpse in an art language which was bound to remain inaccessible to most people of his age. For, inevitably, he worked in the artistic idiom of his own day, and used it in a way which to normal eyes seemed a confession of his own technical inadequacy. In his poetry he uses the romantic imagery of Ossian and Gray to achieve results which are a startling anticipation of Wordsworth in the Lyrical Ballads. In his painting he has a variety of contemporary working traditions to draw on. While serving his apprenticeship as an engraver he had made a great number of drawings of medieval tombs, and the impress of the medievalism which he imbibed, consciously or unconsciously, while engaged on

this work is evident throughout his original drawings. At the other extreme he was enthusiastically aware of the current academic tradition of drawing the nude figure and of the Michelangelesque emphasis on muscular development which was already being put at the service of expressionistic literary illustration by Fuseli. In this he was touching the deepest aspirations of the English academic circles of the time: the desire to produce a body of historical painting, in which the human figure was the vehicle of an epic message, worthy to be put beside the schools of Italy and Flanders.

Blake put these strands of current ideas to completely individual use. He exaggerates everything in his need to express the overflowing of emotion and enlightenment. When Job is met by his friends – Job's comforters – they are mostly, in Blake's eyes, of patriarchal age, terribly old and bowed down, with long, white, flowing beards. His protagonists have the large, staring eyes of the visionary or the madman. They express prostration by being bent to the ground, nobility by upstanding gesture, and yearning with both arms outstretched to the sky. Taking the symbolism of Milton quite literally, God uses a golden compass to strike out the universe. Outspoken expressionism of this type sometimes verges on caricature, but in Blake it generally does not step beyond the limits of what we can accept (Fig.88).

Blake was inexhaustibly fertile in technique. He was trained in the most solid tradition of eighteenth-century line engraving; but he found, when he came to work out his own ideas, that it was difficult to express them in this medium or through oil and watercolour. So he developed a method of relief etching, to which he applied colour by hand, to make of his hand-printed books of poems something as glowing as medieval illuminated manuscripts. When he was over sixty

89 William Blake *The Inscription over Hell Gate* ▷

HELL *Canto 3*

101 J.F. **Lewis** *The Hhareem*

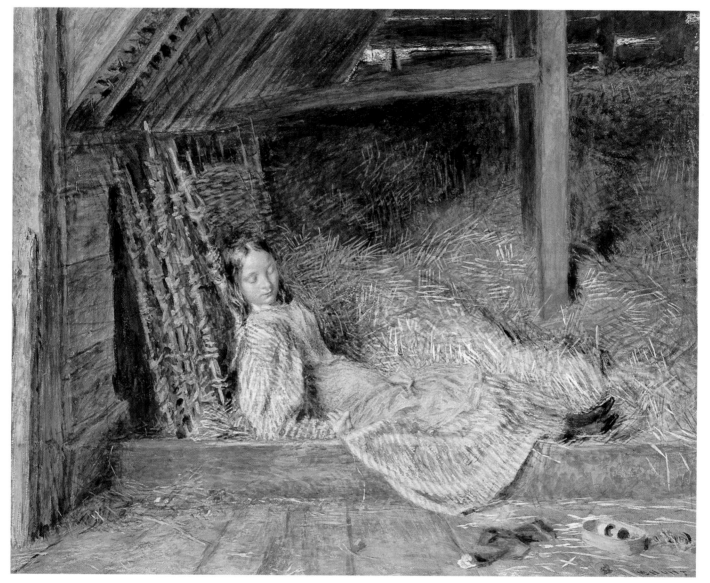

102 **William Henry Hunt** *Slumber*

he turned to what was for him the novel medium of the woodcut, and made a dozen designs for Thornton's *Virgil* of which the influence was absolutely vital. So, too, he made what are to all intents and purposes in appearance watercolour drawings, but which are in fact colour prints, often derived in somewhat recondite fashion as off-prints of frescoes and so forth, and then coloured again or finished by hand.

Apart from the truths which he quite simply believed were revealed directly to his inner sense by vision or trance, Blake's thought was dominated by reverence for the past and in particular for certain literary monuments, of which the Bible was paramount. Even more than in illustrating the sometimes obscure symbolism of his own epics, he gave most satisfactory expression to his graphic skill in large cycles of designs which he prepared for the illustration of some of those works. Amongst such cycles are the illustrations to Young's *Night Thoughts*, the designs for the Book of Job and, in the last years of his life, his illustrations for Dante's *Divine Comedy*.

The illustrations for the *Divine Comedy* display his imagination at its grandest and most communicable. Here, as in the illustrations to Thornton's *Virgil*, the figures, gigantic and larger than human as they are, fit naturally into the Titanic and Tartarean background of Dante's, and Blake's, conceiving. The deceptively sylvan entrance to Hell is an ironic contrast to the scenes of horror which are to follow (Fig.89). In one of the few perfectly satisfying transmutations of literary works into pictures, Blake has made it possible for us to believe in both the horror and the pity of the Inferno; he has communicated the infinite purgation of Paolo and Francesca which causes Dante to swoon with grief beside his impassive guide.

In the last ten years of his life, thanks to a meeting with the young artist John Linnell, William Blake became the centre of a small group of young and like-minded men who venerated him and to whom he transmitted his wisdom. Through them he re-entered in due course the main stream of English art. Among the friends was John Varley, who, with his astrological pre-dilections, was fascinated by Blake's faculty of summoning visions, or visual hallucinations, as we should probably call them. But mention of Varley serves to recall that he was an artist whose supernormal or psychic gifts in life were not reflected in his art, in vivid contrast to Blake who had, as far as anyone can, the power of translating one dimension of experience into another.

These friends of Blake were – besides Linnell and Varley – Calvert, Richmond, Palmer and F.O. Finch. Of these Calvert made a few early idylls of a haunting poetry before devoting himself to a reconstruction of the Grecian mythology (Fig.90). Two disciples who are of more direct relevance in following the course of English watercolour are Finch and Samuel Palmer. Francis Oliver Finch was of a calm, contemplative and poetical temperament. He said that Blake 'struck him as a new kind of man, wholly original, and in all things', and Finch's own bent towards a mystical outlook is shown by his adhesion to the doctrines of Swedenborg. He was one of the pupils to whom Varley taught the craft of watercolour without suffocating their own original outlook. There is no direct resemblance between Finch's style and the work of Blake; the influence of the latter is rather to be traced in a certain suffused lyricism. Finch almost entirely creates in terms of the ideal landscape compositions whose derivation from Italian practice has been described. He gives a new melancholy and a new nostalgia to the forms used by George Barret, junior, whom he most closely resembles; and he is perhaps the

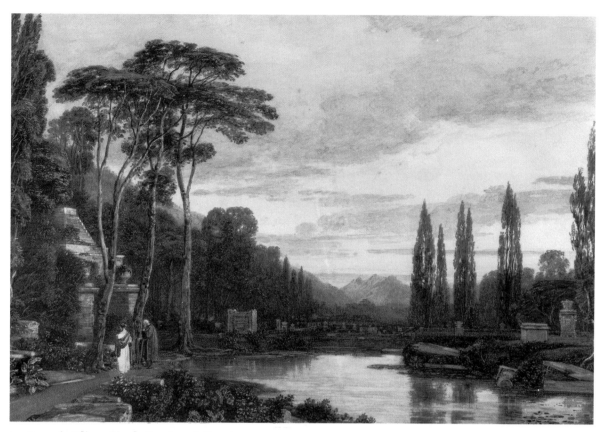

91 Francis Oliver Finch *Evening: A Cemetery*

last orthodox exponent in England of the landscape methods directly derived from Claude (Fig.91).

Samuel Palmer is an even more notable figure amongst the skilful but sometimes prosaic topographers of the mid nineteenth century. His first meeting with William Blake was a stringent test of his earnestness and sincerity. 'Do you work with fear and trembling?' Blake asked him. 'Yes, indeed.' 'Then you'll do.' In an unworldly enthusiasm for the principles of purity in art advocated by Blake, he withdrew to the then isolated Kentish village of Shoreham. The unspoiled country life around him provided motifs and inspiration for an imagination already exalted by the reading of Milton, the Bible and the Latin pastoral poets. Unlike Blake, whose technical command over his visionary faculty seem to have been greatest in the last years of his life, Palmer was at his most perceptive and original in his twenties. The drawings and watercolours of his which are now most appreciated are those of this Shoreham period: they include the remarkable *In a Shoreham Garden* (Fig.92), in the Victoria and Albert Museum, in which a woman is seen at the end of one of the paths of a truly enchanted garden, full of the colour and forms associated with children's memory of gardens, and with a tree in incredible blossom over all.

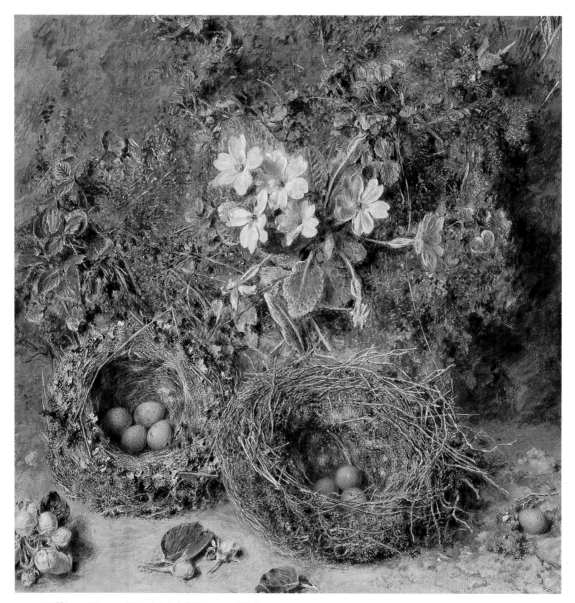

103 William Henry Hunt *Birds' Nests and Primroses*

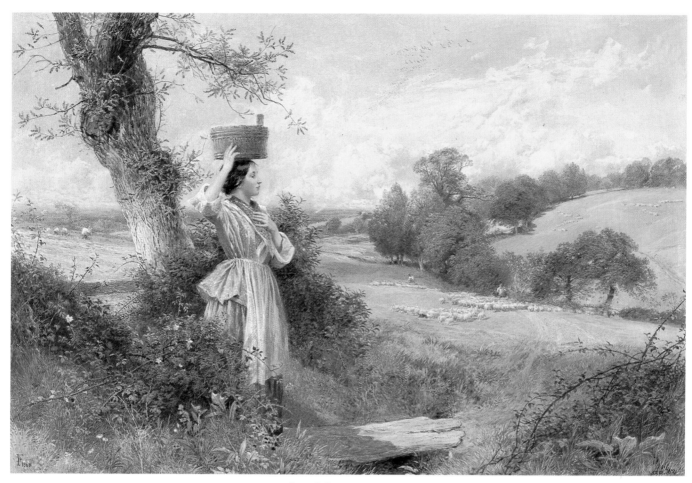

104 Myles Birket Foster *The Milkmaid*

93 Samuel Palmer
Lane and Shed, Shoreham

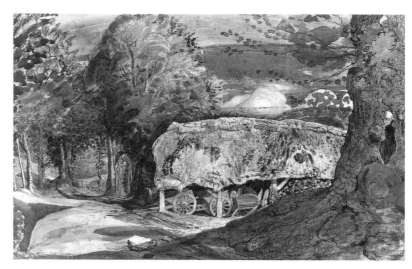

94 Samuel Palmer *Ancient Rome*

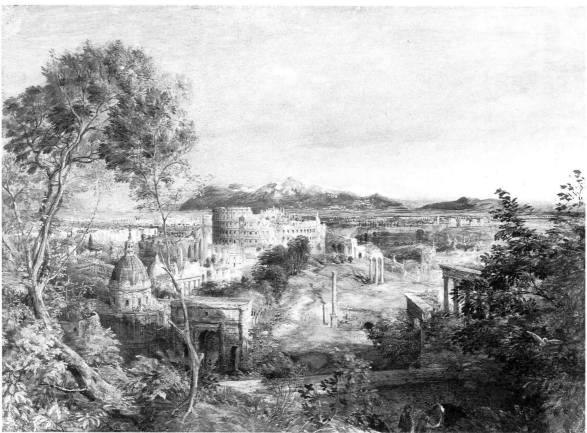

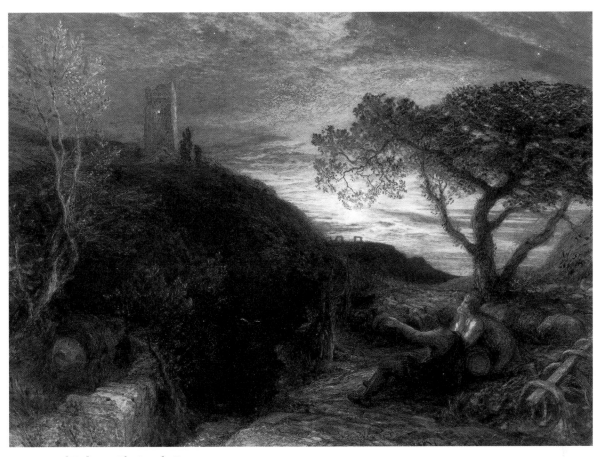

95 **Samuel Palmer** *The Lonely Tower*

Even his observation of a moss-covered barn is charged with visionary excitement (Fig.93). After his Shoreham period Palmer came more nearly to terms with the current commercial idea of what a watercolour should look like; but he did not lose his fascination with technique, which seems composed of casual, careless scrumbling and scribbles, but is both accurate and vigorous, nor did he lose the essential delight of his perception of the outer world. His Italian scenes are rich with applied textures which add exuberance to his record of antiquity (Fig.94). Again in his last years he turned in memory to his Shoreham days and sought to recapture that 'light that never was on land or sea', particularly in a series of watercolours illustrating Milton in which the Claudean evening light illuminates the fleeces of the homeward-returning flock or the melancholy scholar wishes that his

lamp at midnight hour
Be seen in some high lonely tower (Fig.95)

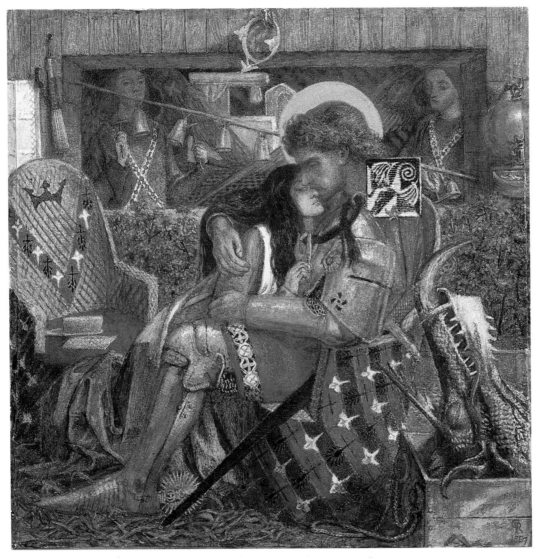

105 Dante Gabriel Rossetti *The Wedding of St George and Princess Sabra*

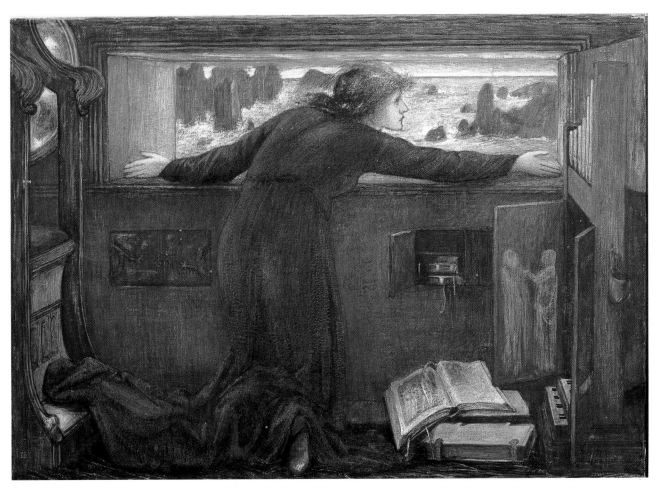

106 Edward Coley Burne-Jones *Dorigen of Bretaigne longing for the Safe Return of her Husband*

97 John Linnell *Collecting the Flock*

John Linnell showed much the same liberation of technique in his watercolour style. In his extremely long career he was an originator at many different levels. By 1806, when he was fourteen years old, he had been noticed by Sir George Beaumont for the extraordinary fidelity of his scenes of courts and alleys. He brought a distinctive style of stippling to his portrait miniatures and drawings (Fig.96). He had the penetration to sense Blake's genius and to employ him on his illustrations to Dante when he had no other commissions. In return, some of the lyricism of Blake's woodcuts to Thornton's *Virgil* was communicated to Linnell's landscapes (Fig.97).

The desire to escape from the harsher realities of nineteenth-century life, into an interior world of fantasy, was not felt only by artists who shared

a sympathy with Blake's mysticism. Richard Dadd had begun as a traditional landscape painter, but his travels in Greece and the Middle East brought on an attack of madness during which he murdered his father. Withdrawn into his own world in his confinement in asylums he tapped an original

98 Richard Dadd *Sketch to illustrate the Passions: Treachery*

99 Richard Doyle *Under the Dock Leaves – an Autumnal Evening's Dream*

vein of fantasy. One of his obsessions was his painting of fairy subjects (Fig.98). This reflected a novel taste of the early Victorian age. Amongst the many other artists who delighted in folklore and the contrast in scale between reality and the little persons in the fairy stories was Richard Doyle. Doyle, whose surprisingly phallic design was used on the cover of Punch till quite recently, was one of the earliest artists to use the naiveties of children's drawings as a basis for his own style. His caricatures of social life in the 1850s are drawn with a consciously childish touch, and the same spirit of infantilism pervades his highly accomplished drawings of fairy land (Fig.99).

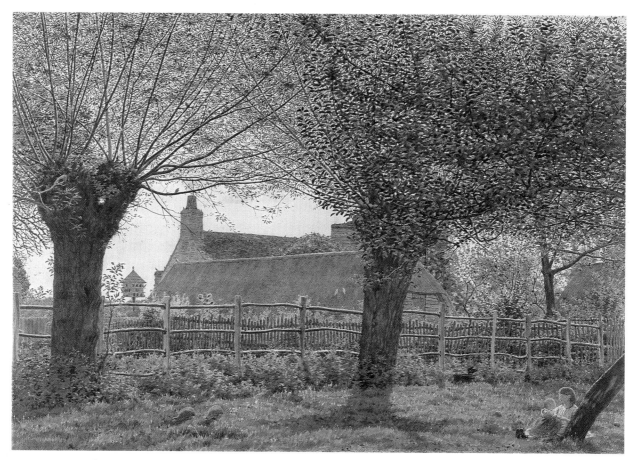

110 **George Price Boyce** *At Binsey, near Oxford*

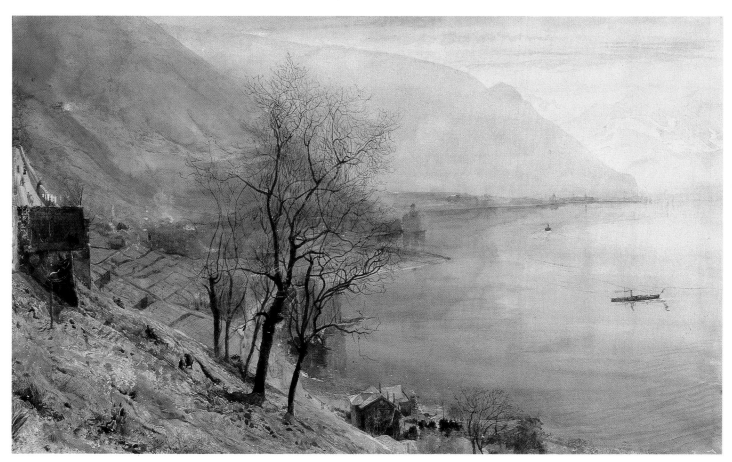

111 John William Inchbold *View above Montreux*

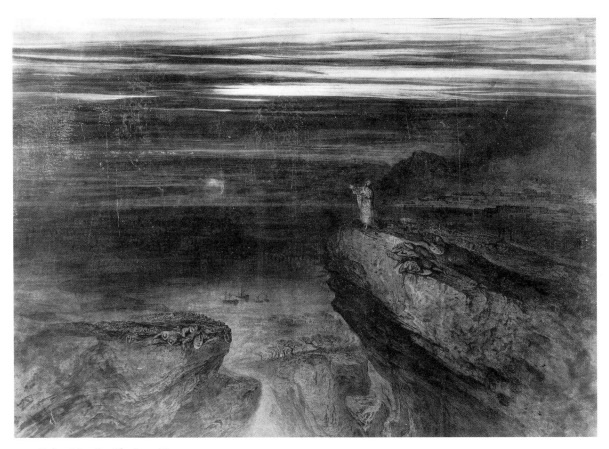

100 John Martin *The Last Man*

The careers of Blake, Calvert, Palmer and Linnell are sufficient to show that the nineteenth century was fertile in breeding artistic nonconformists. Even in this age of individualists John Martin stands out by the scope of his ambition. He pursues the sublime by exploiting its dependence upon vastness of scale. The projector of great schemes for public works, he is representative of the epoch of vast architectural and engineering achievement. His work was conceived on a monumental, panoramic scale. The progressive thrust of the age of the railway is combined with an old-fashioned fundamentalism in his concept of *The Last Man*, dwarfed by the illimitable universe (Fig. 100).

3 The later Victorians and the Moderns *J.F. Lewis, Rossetti, Whistler, Wyndham Lewis, Paul Nash, Graham Sutherland*

In the main the artists so far considered took the view that watercolour was properly a transparent medium. They held that in its application to the white-paper ground full advantage should be taken of its luminosity, and of its capacity to reflect light through the pigmented washes, if they were applied thinly enough. The Victorians were conscious of living in a progressive and experimental age, and were not prepared to take any tradition, however long established, on trust. So variations and developments of the earlier technique began to appear, and took control in the middle years of the century. The most important change came from their encouragement of the use of body colour, in which Chinese white is mixed with the pigments to make them opaque. Although the characteristic lightness of thin washes is lost in this method it has the countervailing advantage of making it possible to render the finest detail of the gradations of colour, light and shade. Its adoption suited the taste of the time for brilliant colour and for meticulous detail.

A pioneer of the new style was J.F. Lewis, whose more revolutionary work burst on the artistic world like a revelation when exhibited in 1850. Lewis had begun his career travelling in the footsteps of David Roberts to Spain and Egypt. But then he diverged from the customary life of the topographical painter. He felt the enchantment of the East, and spent ten years in Cairo in a kind of somnambulistic haze. But his *dolce far niente*

existence had not been pure idleness. When he showed *The Hhareem* at the Old Watercolour Society it was immediately recognized as the masterly embodiment of a new approach to watercolour painting (Fig.101). It sums up the results of his indolent study of the people of Cairo and his delicate observation of the nuances of intense light falling through lattices upon the interiors; but there is nothing indolent about its execution. He could only have achieved this degree of fidelity to observed appearances by the minutely divided strokes and touches of body colour which form the base of his painting technique.

The public success of *The Hhareem* was immense. It impelled Ruskin to enrol the artist as an honorary Pre-Raphaelite, though in truth he had little in common with them. Ruskin also applauded his employment of body colour, which he said had all the advantages of oil paint without such disadvantages as mess and smell.

Lewis owed his success partly to the fact that he had been out of the public attention for ten years, and partly because his exotic subject matter was so well suited to his technique. He had been anticipated in the use of body colour for the exploration of colour variations in minute detail by a number of other artists, amongst the most conspicuous of whom is William Henry Hunt. He had begun his long career in the eighteenth-century tradition, using line and wash in the manner of the old 'stained drawing'. Sensing a

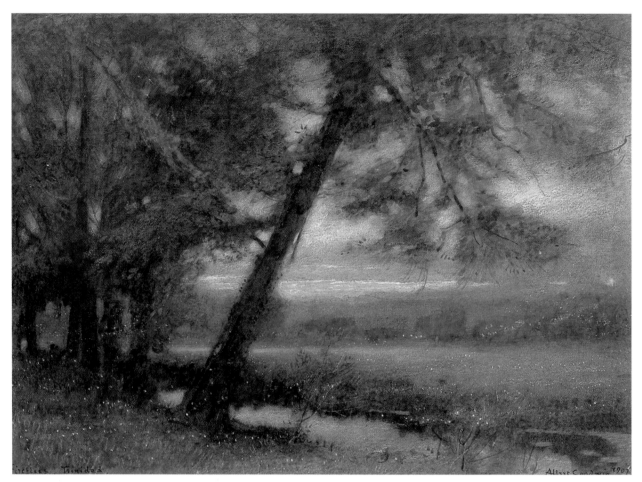

113 **Albert Goodwin** *Fireflies, Trinidad*

117 **Frederick Walker** *Autumn* ▷

growing shift in interest from the topographical to the narrative, he began to make figure compositions in which the attention is focused upon a single figure in an interior (Fig.102). He explores the effects of light with a carefully controlled stippling. Some of his best figure subjects are found amongst his humorous studies of a boy, smoking his first cigar or eating too much of a tempting pie. Ruskin, who admired Hunt sufficiently to give an analysis of his work and to divide it into a variety of categories totally disapproved of these excursions into humour. But he shared the general admiration for Hunt's fruit and flower paintings. These gained for him the name of 'Bird's Nest' Hunt by which he is usually known (Fig.103). He made his still lifes from the object before his eyes, painting the detail in a refined mixture of body and watercolour which was so much under his control that he could convey not only the bloom on the plum but the smudge where the bloom had been removed by handling.

Lewis and Hunt were forerunners in an aesthetic shift which is apparent in the watercolours of the next thirty years, towards brilliance of colour and minuteness of touch. Birket Foster applies these principles to landscapes in which the emphasis is laid on the charm of summer fields and country lanes and the inhabitants are idealized into the best behaved children or worthy, handsome peasantry (Fig.104). He is in the direct line of descent from Lewis, whose *The Hhareem* he owned; he evidently made good use of its technical lessons when forming his own mature style.

The Pre-Raphaelites were fully in sympathy with any such technical innovations. They added to this Victorian break with tradition a spiritual shift away from the pressure of actuality, and sought to develop the imaginative elements which had not been dominant features in the exhibiting institutions. To recapture a magical and mystical element which they felt had been neglected they sought in their most individual works to seek refuge from the realities of current life and shelter in the glories of a medieval dream. They treated watercolour almost as if it were oil paint, placing one layer over another, scratching it, and adopting whatever devices led to their main goal. Rossetti worked over some of his watercolours many years after their original conception. But these unorthodox methods produced the result at which they were aiming; they did produce pictures which glowed like stained glass and proclaimed their fascination with the past in both composition and colour.

Rossetti perhaps expressed himself most truly in his watercolours; at least in his oil paintings he often blurs his intentions with a rather heavy and ineffective use of paint, and his pencil and pen drawings, exquisite and revealing though they are, lack that final element of colour which was the quality which most appealed to him in the medieval world picture. His watercolours, predominantly illustrations of Dante, Shakespeare or legend, have about them a haunting nostalgia for the past. One of the followers of the Pre-Raphaelites spoke of the drawing by Rossetti of the *Wedding of St George and Princess Sabra* (Fig.105) as a 'dim golden dream', and the phrase precisely expresses the appeal of this rarefied and emotional art.

Of the Pre-Raphaelite followers Burne-Jones was most in tune with this reversion to the medieval past. He had an unusual sense of colour and its juxtaposition, and was able to develop this trait in his watercolours. His *Dorigen of Bretaigne* shows a typically etiolated maid, whose lovesick longing for her absent husband, described by Chaucer in *The Franklin's Tale*, is emphasized by the cramped position imposed upon her by his composition (Fig.106).

107 John Everett Millais *The Eve of St Agnes: an Interior at Knole near Sevenoaks*

The early drawings in which Millais first broke ranks with academic standards were outline drawings with a heavily German accent. By the time he came to use watercolour he had worked through his more rebellious tendencies. In fact he had so far overcome the hostility in conventional circles to his innovations that he was chosen to illustrate *Orley Farm*, and showed himself in full accord with Trollope's very representative view of British life. Yet the sense of wonder and the

precocity of technique which are the strength of his early paintings recur from time to time, especially when he is painting a theme from the poets, as in his watercolour of *The Eve of St Agnes*, in which he recaptures the moonlit romance of Keats's tale (Fig. 107).

Superficially, the visit which William Holman Hunt paid to the East, including the Holy Land, might seem parallel to those paid before him, by artists such as Robert and Lewis. But Hunt arrived

120 **Robert Walker Macbeth** *Greeting the Postman*

122 James McNeill Whistler *Mother and Child on a Couch*

108 **William Holman Hunt** *Nazareth*

encumbered with the full doctrine of Pre-Raphaelite truth to Nature, and in an evangelistic spirit, which he embodied in his famous oil painting *The Scapegoat*. Whatever view we may form about his increasingly idiosyncratic colour sense there can be no doubting the sincerity with which he sets about painting religious parables in their Biblical setting, nor of his emotions in visiting the holy shrines of Christianity (Fig. 108).

Opponents of the Pre-Raphaelites warned that it fostered unhealthy tendencies. Their forebodings were realised in the work of Simeon Solomon, in which the decadence foreshadowed by Baudelaire and Swinburne bore spectacular fruit. He succeeded in effecting an entirely individual amalgam of Judaic imagery and themes suggested by the homosexuality which led to his personal ruin (Fig. 109).

Such deviations from decency, propriety and the established order of things were remote from that truth to Nature which Ruskin claimed for the Pre-Raphaelites. But his criticism was well adapted to the aims of those landscape painters who believed themselves to be following the

precepts of the Brotherhood. Ruskin may himself have influenced them by his criticism, his patronage and his own practice in drawing. But his influence was a limiting one. He was delighted that the new methods could reproduce literal fact, but wanted his artists to limit their observation of the world to chunks of geological material or details of architecture. The most successful amongst this group of landscape painters were those who were able to escape an obsession with detached detail and could introduce broader principles of composition into their paintings.

George Price Boyce was able to bring a unifying vision into the landscapes he painted in the Midlands and the North country (Fig.110). John William Inchbold is another mid-nineteenth-century artist whose sense of light and keenness of colour were enhanced by the example of the

112 **Edward Lear** *Choropiskeros, Corfu*

109 **Simeon Solomon** *A Lady in Chinese Dress*

Pre-Raphaelite movement (Fig.111).

Meanwhile earlier ways of looking at the world were not abandoned. Edward Lear is another globetrotter, driven by his restless temperament to wander over a range of territory remarkable even in those adventurous times; his way of recording the memorable and picturesque scenes he saw, whether in India, Greece, Egypt or Albania, was a wholly individual development of the earliest form of tinted drawing, in which the outline is predominant and the colour laid on in light, very transparent washes (Fig.112).

123 Joseph Crawhall *The Aviary*

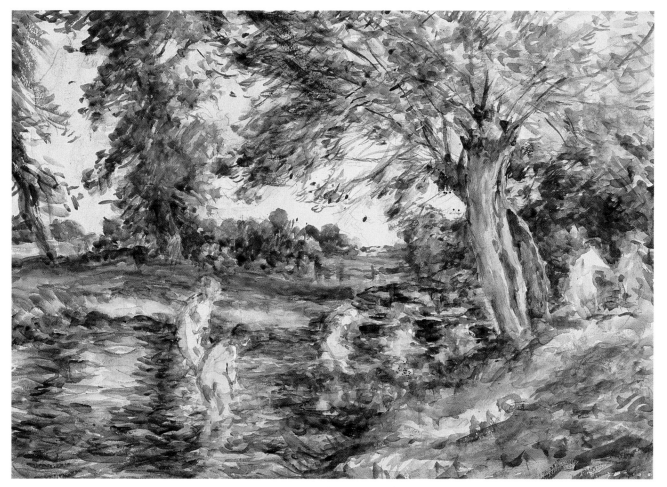

127 Mark Fisher *Boys Bathing*

114 **Helen Allingham** *A Cottage at Chiddingfold*

Albert Goodwin practised a diametrically opposed method, derived from his admiration for Turner, his training by Ford Madox Brown and Arthur Hughes, and a trip to Italy with Ruskin 'to copy objects'. From these diverse influences he developed a richly mottled and stippled style, and incorporated a pen line with his thickly textured watercolour. His travels were even more widespread than Lear's, taking him to the South Seas and the West Indies. Like so many of his contemporaries the most colourful phenomena of light had a fascination for him, a feature exemplified by his watercolour of *Fireflies, Trinidad* (Fig.113).

Even those artists who were most stay-at-home were addicted to a high key of colour; if they could not seek it in the Tropics they could at least find it in the herbaceous border of the country garden. A whole school of watercolourists set about these subjects, of whom the most representative is Helen Allingham. She was married to the poet William Allingham, who was associated with the literary wing of the Pre-Raphaelite movement. Her scenes of Kentish cottages became an almost obligatory feature of exhibitions at the Old Watercolour Society and in collections of the late nineteenth century, and were much imitated (Fig.114).

The idyllic countryside of Birket Foster and Helen Allingham was not of course the only scenery to be found in England in its years of industrial expansion. A few, though very few, artists did set out to record the less picturesque though frequently dramatic, aspects of the British scene. The Scottish-born landscape painter Sam Bough did not shirk this opportunity. In his *View of a Manufacturing Town* (Fig.115), believed to be in Airedale, Yorkshire, he manages to convey, amidst the pollution and the lack of conventional beauty, a sense of the excitement linked with the creation of wealth. Alfred William Hunt, who carried the Pre-Raphaelite attachment to accuracy of detail to an extreme, found another aspect of daily working life in his study of the pier at Tynemouth after it had been damaged by a wreck (Fig.116).

The practice of book illustration received a notable degree of encouragement during the second half of the century through the development of speedy ways of reproduction, particularly through wood engraving. It was also fostered by the spread of illustrated weekly and monthly periodicals. Many of the draughtsmen who were employed to fill the demand worked up their designs into exhibition watercolours, which attained a wide popularity. Millais adopted this practice for some of his illustrations to Trollope.

115 Samuel Bough
View of a Manufacturing Town

116 Alfred William Hunt
*'Blue Lights', Tynemouth Pier –
Lighting the Lamps at Sundown*

128 Gwen John *A Seated Cat*

129 Ambrose McEvoy *The Artist's Wife* ▷

118 Charles Green
*Little Nell aroused by
the Bargemen*

119 A.B. Houghton
*The Transformation
of King Beder*

In the next generation of artists the acknowledged leader of the illustrative school was Frederick Walker. His work is highly wrought and he pays intensive attention to detail and to brilliant colour: qualities which can be seen in his large watercolour *Autumn* (Fig.117). Yet he was conscious of the danger of overlaying the aesthetic effect by too minute an approach, and remarked 'composition is the art of preserving the accidental effect'.

Charles Green was one of the second generation of illustrators of Dickens, one of those who replaced the caricature of Phiz by more realistic representations of the author's episodes and characters. The gulf of feeling which divides his *Little Nell aroused by the Bargemen* (Fig.118) from Phiz's etching of the same scene is a fair index of the change of character which had affected art within twenty years. Phiz was the last exponent of the eighteenth-century tradition of exaggerated distortion and savage humour. It was Trollope's detestation of his style which led him to welcome the realism of Millais's illustration; Green and his contemporaries continued this more subdued approach.

However, Arthur Boyd Houghton did salt a fundamentally realistic vision of domestic life with a sense of the absurd. He enlarged his experience by visits to India and to the United States, and evoked a good deal of ill will by the good-humoured but critical drawings he made of Shaker and Mormon customs. He was able to draw upon his contacts with the East for his illustrations for the *Arabian Nights* (Fig.119). His drawings were welcome to the *Graphic*, a periodical founded to present a radical view of society. But not all the works of the illustrators were pervaded by a sombre propagandist tone, as R.W. Macbeth's *Greeting the Postman* (Fig.120) demonstrates.

Watercolour played an important role in pro-

viding for the collectors who wanted anecdotal pictures like those invented by Walker, Pinwell, Houghton, North and many other illustrators. It was also a main vehicle for the devotees of thatched cottages and gardens of dazzling florescence. But the art of the later nineteenth century was of immense variety, and the medium was called upon by most of its dominant movements. It is a feature of Romanticism to distance itself from the present by travelling in space or time. As the century progressed the frontiers of these explorations were advanced further and further. Themes from the Middle Ages were sufficiently remote and wonderful for the Pre-Raphaelites; in the next generation the Æsthetics sought their escape in the world of Greece and Rome. Albert Moore found that subjects with an undefined Classical reference enabled him to indulge in the creation of unusual colour harmonies which are the real content of his art (Fig.121).

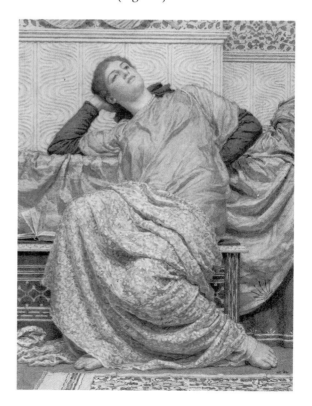

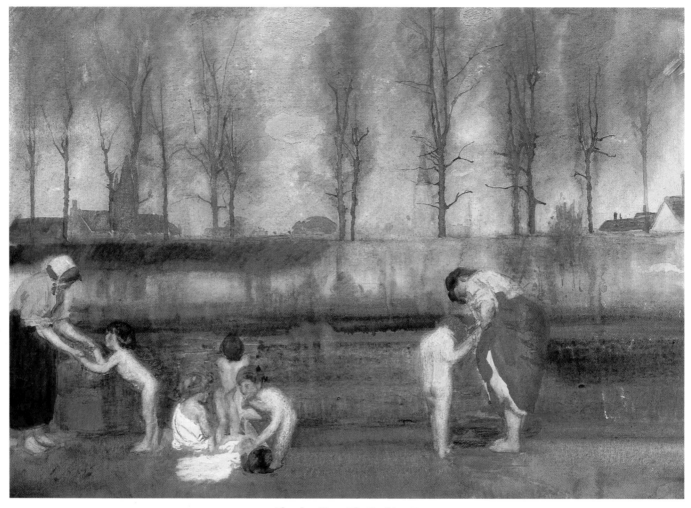

131 Charles Sims *The Bathing Party*

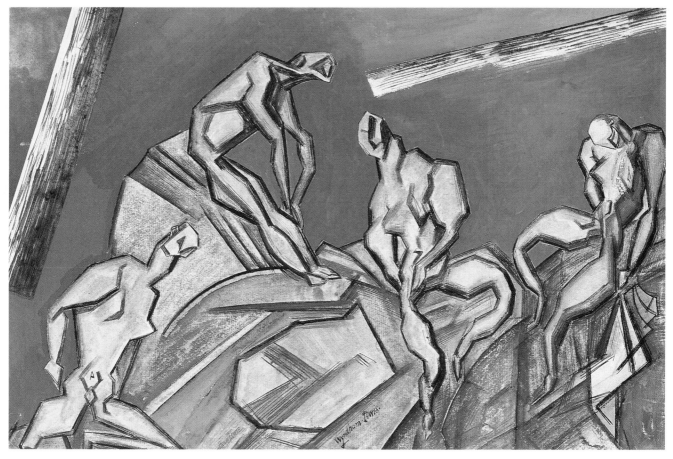

135 Wyndham Lewis *Sunset among Michelangelos*

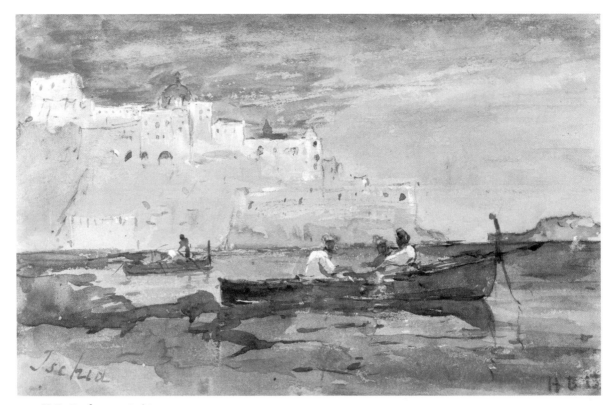

124 H.B. Brabazon *Ischia*

For a brief period in the 1860s Whistler also painted works of the same degree of remoteness from everyday life, finding his ideal Shangri-la in Japan. So close were the methods of Moore and Whistler at the time that an adjudicator had to be found to decide whether either had plagiarized the other's ideas. But in the main Whistler's interests were focused on the world passing in front of his eyes. He brought to England the advantages of having studied in Paris at the time when the ideas of Impressionism were beginning to develop. His injection of a spirit of cosmo-politanism into the inbred and ingrown hierarchies of British art provided a much needed stimulus

for the growth of new ideas here. Most notably he reverted to the earlier conception of watercolour as a medium in which the paramount excellence lies in its use for sketches and in the exploitation of transparent washes (Fig. 122). Both in his own watercolours and in those of his successors, such as Arthur W. Melville and Joseph Crawhall (Fig. 123), we see a revolutionary protest against the dense textures and the body colour of the mid-nineteenth-century draughtsmen such as J.F. Lewis, W.H. Hunt, and Frederick Walker.

This reversion to what was regarded as a purer approach had a fortuitous effect on the fortunes of H.B. Brabazon. In reality a follower of Turner's

later manner, his watercolours were exhibited in the 'nineties, when he was aged seventy, and fitted so neatly into these new tastes that he became fashionable (Fig.124).

It has been apparent how throughout the century the frontiers of travel had been expended by artists in search of new and exotic material. Sir Alfred East was one of the earliest to take advantage of the opening of Japan to the Western world (Fig.125). And though Crawhall did not himself travel in the Orient he was influenced by Chinese techniques of calligraphy and wash drawing in his watercolours.

126 **John Singer Sargent** *Santa Maria della Salute*

125 **Alfred East** *The Entrance to the Temple of Kiyomizu-Dera, Kyoto, with Pilgrims ascending*

The reaction of British artists to the more advanced movements in European art was as cautious as that of the collectors. The New English Art Club was formed in the 'nineties as a focus for those artists who had become aware of Impressionism, but its members did not entirely lose their rather insular note of hesitation about a wholehearted adherence to Continental tenets. This was so even in the case of artists such as Sargent (Fig.126) who had spent much time in Paris, the centre of the avant-garde. But the very insulation of these artists from a close adherence

138 Henry Moore *Pink and Green Sleepers*

130 William Orpen *The Draughtsman and his Model*

to movements and enthusiasms could be a source of strength when it came to working out their own unusual ideas. It may come as a surprise now that Mark Fisher was regarded in his own time as an Impressionist who had also imbibed the spirit of Constable (Fig.127). On the other hand Gwen John's sturdy isolation enabled her to work out a personal obsession with her limited subject matter of cats and portraits (Fig.128).

Ambrose McEvoy altered the concept of society portraiture, representing his sitters in the broad, indistinct washes of the modern style instead of resorting to remorseless detail (Fig.129). Orpen, who was a more orthodox portrait painter, achieved in his drawings an up-to-date interpretation of the age-old theme of the artist and his model, conceived in a mood resembling the realism of H.G. Wells's contemporary novels (Fig.130).

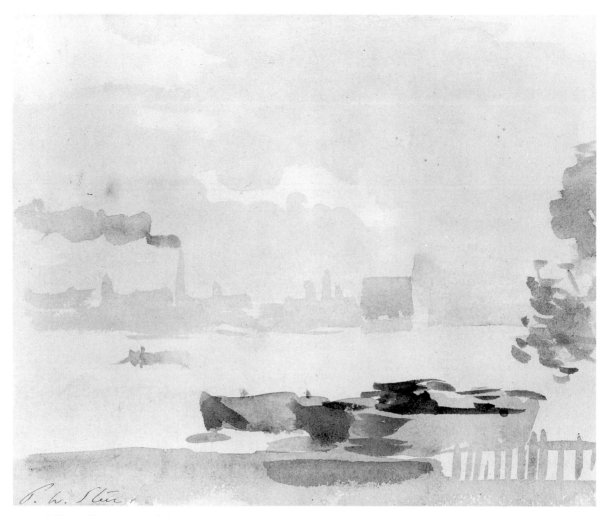

132 Philip Wilson Steer *Chelsea Reach*

Although he was appointed Keeper of the Royal Academy, and therefore had impeccable traditional roots, Charles Sims's relation with that official body were by no means harmonious. But he had an instinctive sense of elegance, and his *The Bathing Party* reveals his talent for decorative design and the evocation of the idyllic mode which prevailed throughout the Edwardian era (Fig. 131).

Wilson Steer, who later became one of the chief exponents of the extremely simplified style of watercolour painting, was in the 'nineties a member of the New English Art Club; but at that time he was primarily concerned with oil painting

146

and did not devote himself to watercolour in any quantity till the late years of his life. When he did, he produced some of the most evanescent and economical renderings of atmosphere which have been seen, and they are a transcription in a less violent key of colour of the later water-colours of Turner and H.B. Brabazon (Fig. 132).

J.D. Innes was another representative figure of English landscape painting in watercolour in the first decade of the twentieth century. As has happened so frequently in the English school of painting, his early death cut short a precociously

able talent. In method he returned to the traditions of Cotman and De Wint, the method of broad colourful washes; indeed, his temperament led him to compose in the highest possible keys of colour. He was fortified in applying the deliberate and solid methods of composition of an earlier age by the precept and practice of Cézanne who, with the other members of the Post-Impressionist group, was beginning to be known in England at about this time (Fig. 133). The character of his art asserted itself definitely and early, and he had already at the time of his death at the age of

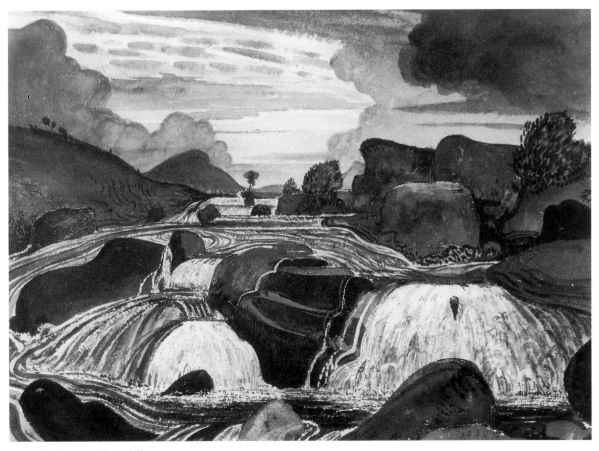

133 J.D. Innes *Waterfall*

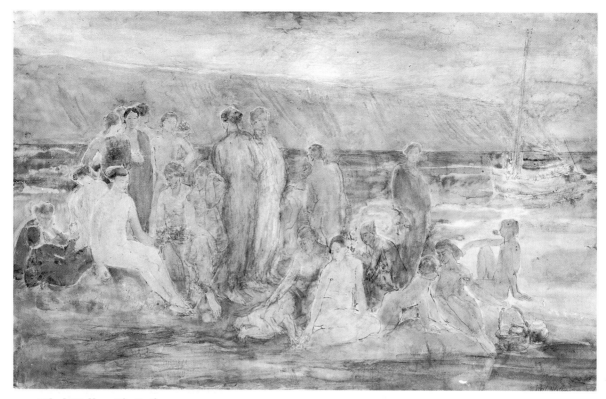

134 **Ethel Walker** *The Bathers*

twenty-six a number of followers, including Derwent Lees and, in his early landscapes, Augustus John. The Edwardians liked to think on a big scale and conceive mural decorations even if the opportunities to carry them out were often withheld. Many of Ethel Walker's compositions embody her conceptions for symbolic decorations, as in her vast design for *The Bathers* (Fig.134).

The arts had entered the twentieth century following the principles which had guided them for the preceding 500 years. They were conceived in the mould formulated by the Renaissance, of veracity of form and truth to Nature. From 1900

a whole wave of new ideas began to disturb this consensus. New theories of form and colour were combined with influences from Japan, the South Seas and Africa to produce a succession of movements: Post-Impressionism, Cubism, Futurism, Vorticism, Constructivism. Each was intended to replace existing doctrines by a new and revolutionary approach, and each attracted fierce opposition. The phrase 'modern art' came to have a pejorative meaning for its opponents and the ideas of the avant-garde were fiercely combatted. As might be expected, the newer concepts were slow in reaching the British Isles.

British art in the nineteenth century had

developed more from within than through conformity to the fashions in Europe. The older-established institutions, the Royal Academy, the Old Watercolour Society, became bulwarks of conservatism in art. When changes did come about they took on a somewhat different form from their European models by being adapted to that nonconforming, somewhat idiosyncratic temperament. The Vorticism which Wyndham Lewis expounded in his revolutionary magazine *Blast* and in his paintings and gouaches (Fig.135) was his own personal response to the Futurism

137 Graham Sutherland *Midsummer Landscape*

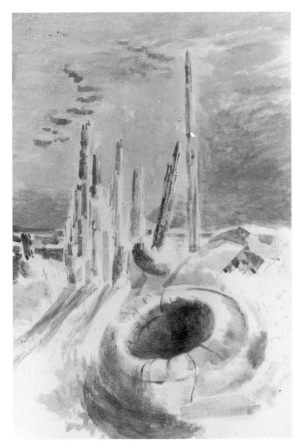

136 Paul Nash *Stone Forest*

propounded in Italy by Marinetti. Paul Nash reacted in a different and more sensitive way to the pressures for change which were sweeping across the Channel. His juvenalia were illustrations of poems conceived almost in a Pre-Raphaelite spirit, and he remained at heart a Romantic illustrator. He drew the horrors of World War I in geometrical forms which have a diluted relationship to the devices of Cubism. In his later and more fully synthesized manner he reintroduced curving lines and rhythmical structures in works which convey a hint of mystical allusiveness (Fig.136).

But no single orthodoxy has emerged from the welter of experiment pursued throughout the middle years of this century. Diverse creeds ranging from pure non-figurative abstraction to remorseless realism have been reflected in the work of the watercolour painters, rather than being led by them. Within the genre there has been an extension of technical innovation, with the development of collage and use of new materials. This has led to the description 'works on paper' often being substituted for that of watercolour.

In a summary account it is only possible to identify a few representative figures to stand for the recent ferment of activity over the whole field of watercolour. Graham Sutherland brought an anthropomorphic interpretation to the natural world and expressed his vision through many of the formal distortions found in some early Romantic landscape painters such as Samuel Palmer (Fig.137). When he was commissioned to record the reaction of the British public to the German air raids, in his series of 'shelter drawings', Henry Moore brought his sense of sculptural form to those remarkable groups of sleeping people. In making his drawings he extended the usual technique of line and wash to include the use of wax crayon which produces a fractured, gem-like texture (Fig.138). Edward Burra brought a sardonic gaze to bear on the louche world of bars, taverns and the Harlem sidewalks (Fig.139). At the other end of the figural spectrum William Scott abstracts from a simple arrangement of shapes a composition of which the prime subject is his consummate

140 William Scott *Composition: Brown, grey and red*

conrol of edges and subtle sense of tone and colour harmony (Fig.140).

The spread of international art exhibitions and periodicals, and the universality of travel, have ensured that art is a common language and that no one can remain long in ignorance of shifts in style or in fashion. In choosing their path amongst the multiplicity of ways open to them the more recent British watercolourists have shown that they prefer a loose connection with theory, and a personal interpretation of it, to rigid adherence to dogma. The confidence with which they use the medium is strengthened by the circumstance that watercolour has been a national method of artistic expression for over two hundred years and has behind it the adventurous and animated history briefly summarized in this account.

◁ **139** **Edward Burra** *Harlem*

NOTES FOR FURTHER READING

These notes for further reading are confined to surveys which deal with the history of the English watercolour as a whole, or substantial sections of that history. These will in their turn direct attention to the numerous monographs on individual artists, many of which are in the form of exhibition catalogues.

Early English Watercolours by Iolo A. Williams, 1952, gives a comprehensive survey of the work of artists born before 1786. *Watercolour Painting in Britain*, 3 vols, 1966-9, by Martin Hardie, is a definitive account of the subject up to the end of the nineteenth century.

The *Concise Catalogue of British Watercolours in the Victoria and Albert Museum* by Lionel Lambourne and Jean Hamilton, 1981, covers the national collection, in which the twentieth century is also strongly represented. It is supplemented by monographs and catalogues of the work of individual artists in that collection: on Paul and Thomas Sandby by Luke Herrmann, 1986, Michael Angelo Rooker by Patrick Conner, 1984, John Varley by C.M. Kauffmann, 1984, Bonington, Francia and Wyld by Marcia Pointon, 1985, and Samuel Prout by Richard Lockett, 1985.

Victorian Watercolours by Christopher Newall, 1987, deals with the productions of the later part of the nineteenth century. The exhibition catalogue *British Landscape Watercolours 1600-1860* by Lindsay Stainton assesses the British Museum's holdings in that field. *Works of Splendour and Imagination: The Exhibition Watercolour, 1770-1870* by Jane Bayard illustrates another specialized aspect, mainly through the collections of the Yale Center for British Art. The present author's *Watercolours: a Concise History*, reprinted 1985, deals with the national school in the wider context of Western painting. *The Tempting Prospect* by Michael Clarke, 1982, traces the rise of watercolour landscape, its teaching and its practice by amateurs.

ILLUSTRATIONS

Measurements are given in centimetres, followed by inches in brackets, height before width.

1 **William Taverner (1703-72)**
A Sandpit at Woolwich
36.3 × 70.2 (14½ × 27⅝)
THE TRUSTEES OF THE BRITISH MUSEUM
This drawing, executed mainly in body colour, once belonged to Paul Sandby.

2 **Thomas Sandby (1723-98)**
The Piazza, Covent Garden
51 × 67.5 (20 × 26½)
THE TRUSTEES OF THE BRITISH MUSEUM

3 **Paul Sandby (1730-1809)**
The Artist's Studio, St George's Row, Bayswater
22.9 × 28 (9 × 11)
THE TRUSTEES OF THE BRITISH MUSEUM
Paul Sandby moved to his house in Bayswater, with its newly built studio in the garden, in 1772.

4 **Paul Sandby**
Morning: View on the Road near Bayswater Turnpike
Signed and dated 1790
64.8 × 89 (25½ × 35)
THE BOARD OF TRUSTEES OF THE VICTORIA AND ALBERT MUSEUM
The inn on the left is The Old Swan, near Paul Sandby's home (Fig.3).

5 **Paul Sandby**
An Ancient Beech Tree
Signed and dated 1794
67.3 × 101.6 (26½ × 40)
THE BOARD OF TRUSTEES OF THE VICTORIA AND ALBERT MUSEUM
This drawing, which is in body colour, was apparently exhibited at the Royal Academy in 1795 with the title *Morning*.

6 **Michael 'Angelo' Rooker (1746-1801)**
Chapel of the Greyfriars Monastery, Winchester
Signed
22.9 × 28.3 (9 × 11⅛)
YALE CENTER FOR BRITISH ART PAUL MELLON COLLECTION

7 **Thomas Hearne (1744-1817)**
The Court House and Guard House in the town of St John's, Antigua
51.1 × 73.6 (20⅛ × 29)
THE BOARD OF TRUSTEES OF THE VICTORIA AND ALBERT MUSEUM

Hearne spent the years 1771-5 making drawings for Sir Ralph Payne, the captain-general and governor-in-chief of the Leeward Islands.

8 **John Webber (c.1750-93)**
View on Krakatoa Island, near the Straits of Sunda
Signed and dated 1786
33.7 × 43.3 (13¼ × 18⅝)
THE BOARD OF TRUSTEES OF THE VICTORIA AND ALBERT MUSEUM

The artist based this watercolour on a sketch made whilst he was draughtsman to Captain Cook's third voyage. The volcanic island was the site of a catastrophic eruption in 1883.

9 **Thomas Daniell (1749-1840)**
Ruins of the Palace of Madura
41.6 × 55.1 (16⅜ × 23¼)
THE BOARD OF TRUSTEES OF THE VICTORIA AND ALBERT MUSEUM

10 **George Chinnery (1774-1852)**
A River Scene
10.3 × 18 (4⅜ × 7⅛)
THE BOARD OF TRUSTEES OF THE VICTORIA AND ALBERT MUSEUM

11 **Thomas Malton, junior (1748-1804)**
The North Front of St Paul's
69 × 27 (27⅛ × 38¼)
YALE CENTER FOR BRITISH ART PAUL MELLON COLLECTION
This watercolour was exhibited at the Royal Academy in 1785 and engraved in *A Picturesque Tour Through the Cities of London and Westminster* 1792.

12 **Edward Dayes (1763-1804)**
Buckingham House, St James's Park
Signed and dated 1790
39.4 × 64.7 (15½ × 25½)
THE BOARD OF TRUSTEES OF THE VICTORIA AND ALBERT MUSEUM

13 **James Miller (flourished 1773-91)**
Cheyne Walk, Chelsea
Signed and dated 1776
40.9 × 62.8 (16⅛ × 24⅞)
THE BOARD OF TRUSTEES OF THE VICTORIA AND ALBERT MUSEUM

14 **Thomas Gainsborough (1727-88)**
Village Scene with Horsemen and Travellers
21.9 × 31.1 (8⅝ × 12¼)
YALE CENTER FOR BRITISH ART PAUL MELLON COLLECTION

15 **James Gillray (1757-1815)**
Cymon and Iphegenia
24.1 × 21.3 (9½ × 8¾)
BY COURTESY OF SOTHEBY'S

16 **Thomas Rowlandson (1756-1827)**
Vauxhall Gardens
48.2 × 74.8 (19 × 29½)
THE BOARD OF TRUSTEES OF THE VICTORIA AND ALBERT MUSEUM

This watercolour was exhibited at the Royal Academy in 1784 and became well known through the aquatint engraving of 1785. The singer is said to

be Mrs Weichsell, mother of the soprano Mrs Billington. On the right the Prince of Wales is seen flirting with 'Perdita' Robinson. The figures in the supper alcove on the left are traditionally supposed to include Johnson and Boswell.

17 Thomas Rowlandson
Entrance to the Mall, Spring Gardens
33.6 × 47 (13¼ × 18½)
THE BOARD OF TRUSTEES OF THE VICTORIA AND ALBERT MUSEUM

18 Thomas Rowlandson
Bodmin Moor
28.4 × 42.9 (11⅛ × 16⅞)
YALE CENTER FOR BRITISH ART PAUL MELLON COLLECTION

19 Francesco Zuccarelli (1702-88)
Market Women and Cattle
38.1 × 55.9 (15 × 22)
THE BOARD OF TRUSTEES OF THE VICTORIA AND ALBERT MUSEUM

The artist came to England in the 1750s and returned to Florence in 1773. This drawing is in body colour.

20 Philip James de Loutherbourg (1740-1812)
Cataract on the Llugwy, near Conway
22.2 × 31.1 (9⅛ × 12¼)
THE BOARD OF THE TRUSTEES OF THE VICTORIA AND ALBERT MUSEUM

21 Jonathan Skelton (c.1735-59)
Lake Albano and Castel Gandolpho
37.2 × 53 (14⅝ × 20⅞)
WHITWORTH ART GALLERY

22 William Pars (1742-82)
A view of Rome taken from the Pincio
Signed and dated 1776
38.5 × 53.8 (15⅛ × 21⅛)
YALE CENTER FOR BRITISH ART PAUL MELLON COLLECTION

23 John 'Warwick' Smith (1749-1831)
Stonework in the Colosseum
Signed
39 × 53.3 (15⅜ × 21)
THE TRUSTEES OF THE BRITISH MUSEUM

154

This watercolour comes from the collection of the 2nd Earl of Warwick, who sent Smith to Italy in 1776.

24 Thomas Jones (1742-1803)
Lake Nemi
Indistinctly dated (?) 1777
28.6 × 42.8 (11¼ × 16¾)
THE TRUSTEES OF THE BRITISH MUSEUM

25 Francis Towne (1739 or 1740-1816)
The Source of the Arveiron
Signed and dated 1781
42 × 31 (16¾ × 12¼)
THE BOARD OF THE TRUSTEES OF THE VICTORIA AND ALBERT MUSEUM

26 Francis Towne
Ariccia
Signed and dated July 11 1781
32.1 × 46.8 (12⅝ × 18½)
THE TRUSTEES OF THE BRITISH MUSEUM

Towne has noted on the backing of this drawing that it was painted when morning sun was breaking over the church and buildings.

27 John Robert Cozens (1752-97)
Mountains in the Isle of Elba
Signed and dated 1780 or 1789
36.8 × 53.7 (14½ × 21⅛)
THE BOARD OF TRUSTEES OF THE VICTORIA AND ALBERT MUSEUM

28 John Robert Cozens
Near Chiavenna in the Grisons
42.5 × 62.2 (16¾ × 24½)
YALE CENTER FOR BRITISH ART PAUL MELLON COLLECTION
This is a finished watercolour made from a sketch on Cozens's journey through Switzerland in 1776 with Richard Payne Knight.

29 John Robert Cozens
The Castle of St Elmo, Naples
Signed and dated 1790
30.5 × 45 (12 × 17¾)
THE TRUSTEES OF THE BRITISH MUSEUM

This drawing was worked up from a sketch made by Cozens on his second visit to Italy, with William Beckford, in 1782.

30 Robert Dighton (1752-1814)
A Windy Day – Scene outside the Shop of Bowles, the Printseller, in St Paul's Churchyard
32 × 24.7 (12¾ × 9¾)
THE BOARD OF TRUSTEES OF THE VICTORIA AND ALBERT MUSEUM

31 John Collet (c.1725-80)
The Asylum for the Deaf
35.3 × 53.5 (13⅞ × 21⅛)
THE BOARD OF TRUSTEES OF THE VICTORIA AND ALBERT MUSEUM

32 Edward Francis Burney (1760-1848)
The Waltz
Signed
47.6 × 68.6 (18¾ × 27)
THE BOARD OF TRUSTEES OF THE VICTORIA AND ALBERT MUSEUM

33 Samuel Hieronymus Grimm (1733-94)
Mother Ludlam's Hole, near Farnham, Surrey
Signed and dated 1781
40.3 × 60 (15⅞ × 23⅝)
THE BOARD OF TRUSTEES OF THE VICTORIA AND ALBERT MUSEUM

34 Samuel Hieronymus Grimm
The Macaroni
Signed and dated 1774
17.4 × 14.7 (6⅞ × 5¾)
THE BOARD OF TRUSTEES OF THE VICTORIA AND ALBERT MUSEUM

35 Samuel Shelley (1750-1808)
Rasselas and his sister
Signed and dated 1804
55.5 × 38.5 (21⅞ × 15⅛)
YALE CENTER FOR BRITISH ART PAUL MELLON COLLECTION
This illustration to Samuel Johnson's *Rasselas* was exhibited at the first exhibition of the Society of Painters in Water-Colours in 1805.

Exhibited at the Royal Academy in 1836 with the quotation 'The mysterious monument of Stonehenge, standing remote on a bare and boundless heath, as much unconnected with the events of past ages as it is with the uses of the present, carries you back beyond all historical records into the obscurity of a totally unknown period.'

This watercolour, made from the drawing-room window of Constable's house in Well Walk, Hampstead, illustrates the convergence of the sun's rays towards the horizon.

This is an illustration to Byron's poem 'The Corsair'.

81 **Clarkson Stanfield (1793-1867)**
A Storm
16.5 × 24.7 (6$\frac{1}{2}$ × 9$\frac{3}{4}$)
THE TRUSTEES OF THE BRITISH
MUSEUM

82 **George Scharf (1788-1860)**
*The Gallery of the New Society of Painters
in Water-Colours, 1834*
Signed and dated 1834
29.6 × 36.7 (11$\frac{5}{8}$ × 14$\frac{1}{2}$)
THE BOARD OF TRUSTEES OF THE
VICTORIA AND ALBERT MUSEUM

83 **William Turner of Oxford
(1789-1862)**
Donati's Comet 1858
25.7 × 36.6 (10$\frac{1}{8}$ × 14$\frac{3}{8}$)
YALE CENTER FOR BRITISH ART
PAUL MELLON COLLECTION
This was exhibited at the Old Water-
Colour Society in 1859 as *Near Oxford –
Half-past 7 o'clock P.M., Oct.5, 1858.*

84 **George Cattermole (1800-68)**
*Macbeth instructing the murderers
employed to kill Banquo*
34 × 49.2 (13$\frac{3}{8}$ × 19$\frac{3}{8}$)
THE BOARD OF TRUSTEES OF THE
VICTORIA AND ALBERT MUSEUM

This illustrates Shakespeare's *Macbeth*,
Act 2, scene i.

85 **Henry Edridge (1769-1821)**
*Thomas Hearne in Ashstead Churchyard,
Surrey*
Signed and dated 1800
33 × 25.4 (13 × 10)
THE BOARD OF TRUSTEES OF THE
VICTORIA AND ALBERT MUSEUM

86 **Alfred Edward Chalon (1781-1860)**
The Opera Box
46.9 × 34.6 (18$\frac{1}{2}$ × 13$\frac{5}{8}$)
THE TRUSTEES OF THE BRITISH
MUSEUM

87 **Eugène Louis Lami (1800-90)**
Scene in Belgrave Square
Signed

14.6 × 24.8 (5$\frac{3}{4}$ × 9$\frac{3}{4}$)
THE BOARD OF TRUSTEES OF THE
VICTORIA AND ALBERT MUSEUM

88 **William Blake (1757-1827)**
The River of Life
Signed
30.5 × 33.6 (12 × 13$\frac{1}{4}$)
THE TATE GALLERY, LONDON

According to Blake's inscription, the
drawing illustrates the first two
verses of Revelations, Chapter 22: 'And
he shewed me a pure river of water of
life, clear as crystal, proceeding out of
the throne of God and of the Lamb. In
the midst of the street of it, and on
either side of the river, was there the
tree of life, which bare twelve manner
of fruits, and yielded her fruit every
month; and the leaves of the tree were
for the healing of nations.'

89 **William Blake**
The Inscription over Hell Gate
Signed
52.7 × 37.4 (20$\frac{3}{4}$ × 14$\frac{3}{4}$)
THE TATE GALLERY, LONDON

In the inscription over the gate Blake
gives a version from memory of Dante's
'lasciate ogni speranza voi ch'entrate'
(abandon hope all you who enter here).

90 **Edward Calvert (1799-1883)**
A Primitive City
Signed and dated 1822
6.8 × 10.2 (2$\frac{5}{8}$ × 4)
THE TRUSTEES OF THE BRITISH
MUSEUM

91 **Francis Oliver Finch (1802-62)**
Evening: a Cemetery
37.7 × 55.8 (14$\frac{7}{8}$ × 22)
THE BOARD OF TRUSTEES OF THE
VICTORIA AND ALBERT MUSEUM

92 **Samuel Palmer (1805-81)**
In a Shoreham Garden
28.3 × 22.3 (11$\frac{1}{8}$ × 8$\frac{3}{4}$)
THE BOARD OF TRUSTEES OF THE
VICTORIA AND ALBERT MUSEUM

93 **Samuel Palmer**
Lane and Shed, Shoreham
27.8 × 45 (11 × 18)
THE BOARD OF TRUSTEES OF THE
VICTORIA AND ALBERT MUSEUM

94 **Samuel Palmer**
Ancient Rome
38.7 × 56.5 (15$\frac{1}{4}$ × 22$\frac{1}{4}$)
BIRMINGHAM MUSEUM AND ART
GALLERY

95 **Samuel Palmer**
The Lonely Tower
51.1 × 70.8 (20$\frac{1}{8}$ × 27$\frac{7}{8}$)
YALE CENTER FOR BRITISH ART
PAUL MELLON COLLECTION
This illustration to Milton's *Il Penseroso*
was exhibited at the Old Water-Colour
Society in 1868. Palmer also etched this
subject.

96 **John Linnell (1792-1882)**
Mrs Wilberforce and her child
Signed and dated 1824
36.2 × 26.7 (14$\frac{1}{4}$ × 10$\frac{1}{2}$)
YALE CENTER FOR BRITISH ART
PAUL MELLON COLLECTION
This watercolour of the daughter-in-law
of the philanthropist William Wilberforce
is painted on gesso laid on panel.

97 **John Linnell**
Collecting the Flock
Signed and dated 1862
26 × 33.6 (10$\frac{1}{4}$ × 13$\frac{1}{4}$)
THE BOARD OF TRUSTEES OF THE
VICTORIA AND ALBERT MUSEUM

98 **Richard Dadd (1817-86)**
*Sketch to illustrate the Passions:
Treachery*
Signed and dated 1853
35.2 × 24.7 (14 × 9$\frac{3}{4}$)
YALE CENTER FOR BRITISH ART
PAUL MELLON COLLECTION

99 **Richard Doyle (1824-83)**
*Under the Dock Leaves – an Autumnal
Evening's Dream*
Signed and dated 1878
49.9 × 77.6 (19$\frac{5}{8}$ × 30$\frac{1}{2}$)
THE TRUSTEES OF THE BRITISH
MUSEUM

INDEX OF ARTISTS